異鄉之用

Trilogy of a Taipei Migrant

maniniwei

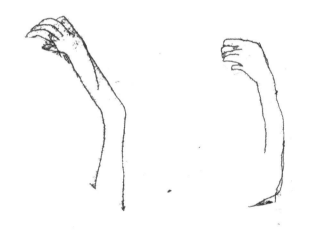

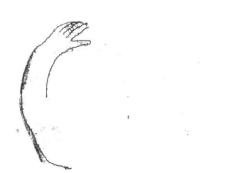

作者

馬尼尼為 maniniwei 馬來西亞華人，苟生臺北逾二十年。美術系所出身卻反感美術系，三十歲後重拾創作。作品包括散文、詩、繪本，著有：《帶著你的雜質發亮》、《我不是生來當母親的》、《以前巴冷刀現在廢鐵爛》、《馬惹尼》、《我的美術系少年》、《馬來鬼圖鑑》等十餘冊，最近作品為散文集《多年後我憶起台北》，可視為本書圖畫版姐妹作。

2020 年獲 OPENBOOK 好書獎「年度中文創作」；桃園市立美術館展出和駐館藝術家；2021 年獲選香港浸會大學華語駐校作家、國家文化藝術基金會〈臺灣書寫專案〉圖文創作類得主、鍾肇政文學獎散文正獎、打狗鳳邑文學獎散文優選、金鼎獎文學圖書獎；2022 年獲台北文學獎年獎類入圍。

曾任臺北詩歌節主視覺設計，作品三度入選臺灣年度詩選、散文選，獲國藝會文學與視覺藝術補助數次，現於博客來 OKAPI、小典藏撰寫讀書筆記和繪本專欄。同事有貓三隻：阿美、來福、巧巧，每天最愛和阿美鬼混；也是動物收容所小小志工。

Fb / IG / website：maniniwei

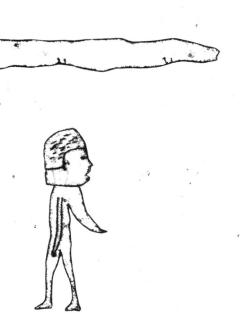

目錄
content

Mrs Basin

盆地太太

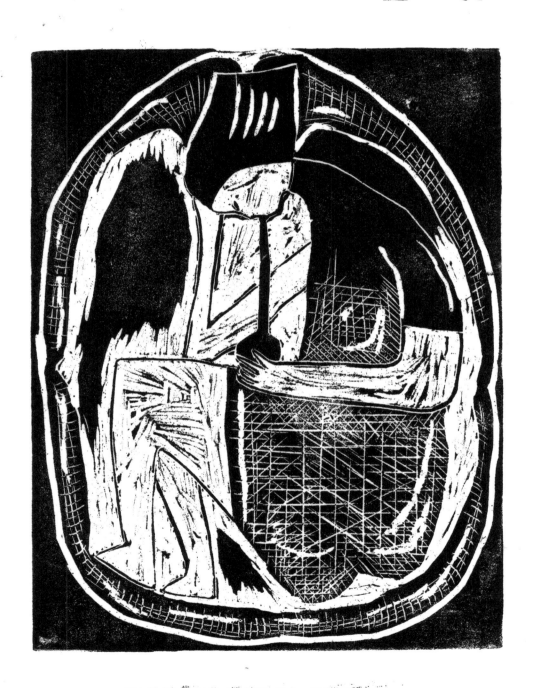

異鄉人既不是活的，
也不是死的，
無法清點。
他們像幽靈。*

* 改寫自Primo Levi，《若非此時，何時？》，翁海貞譯。頁9
　「...失蹤的人既不是活的，也不是死的，無法清點。他們像幽靈。」
* Modified from *Se non ora, quando?* (If not now, when?) by Primo Levi
　"…those missing in action are neither living nor dead and cannot be counted. They're like ghosts"

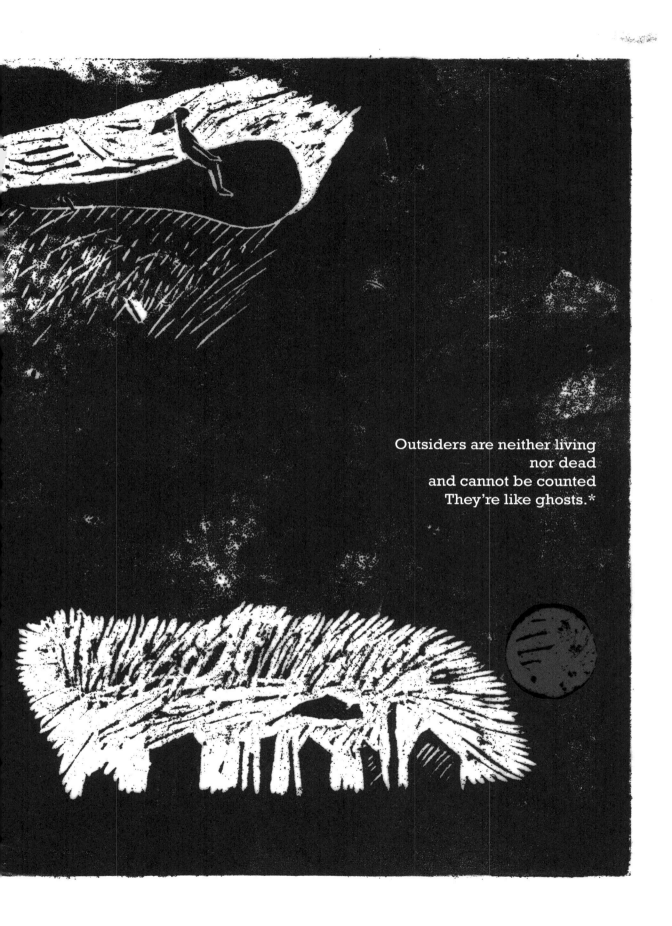

Outsiders are neither living
nor dead
and cannot be counted
They're like ghosts.*

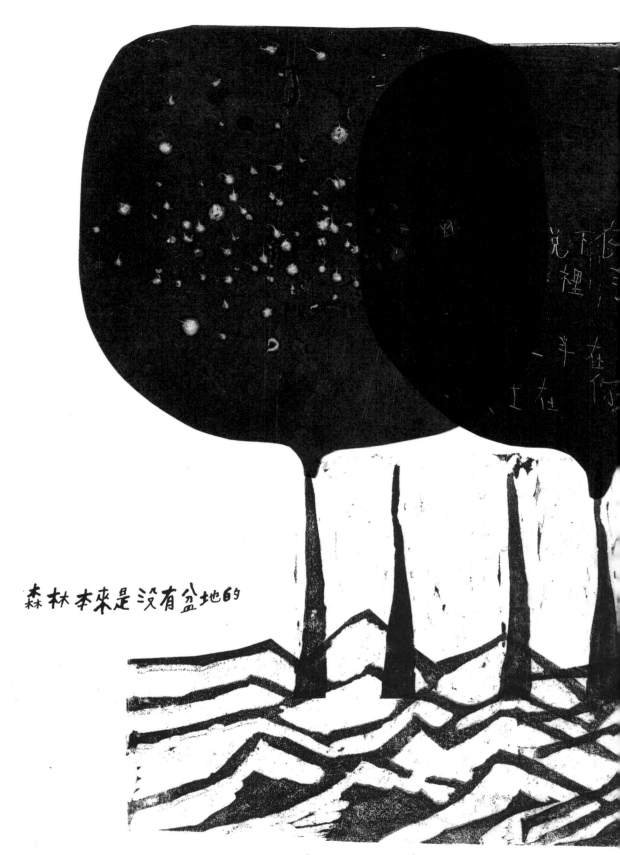

森林本來是沒有盆地的

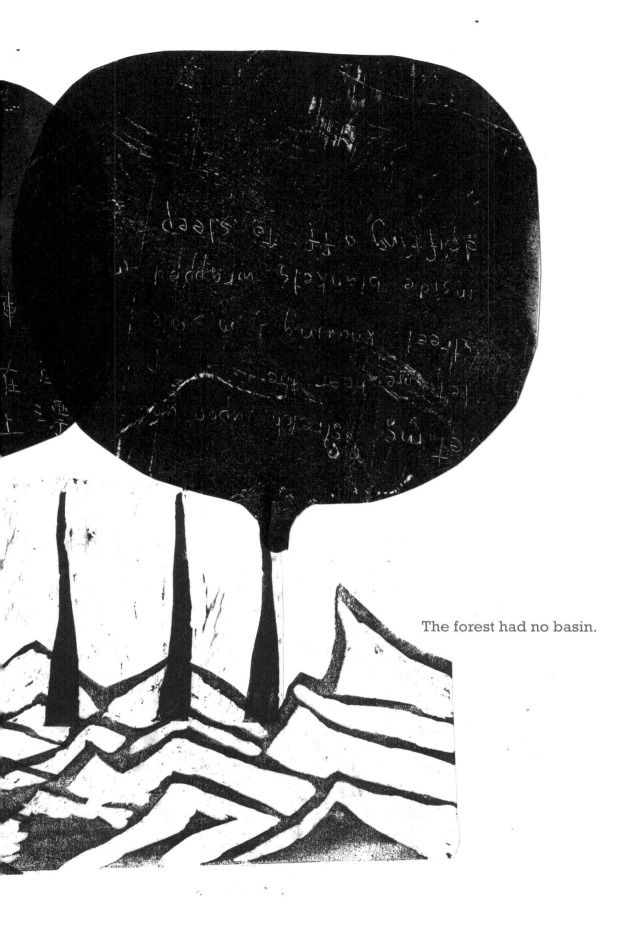

The forest had no basin.

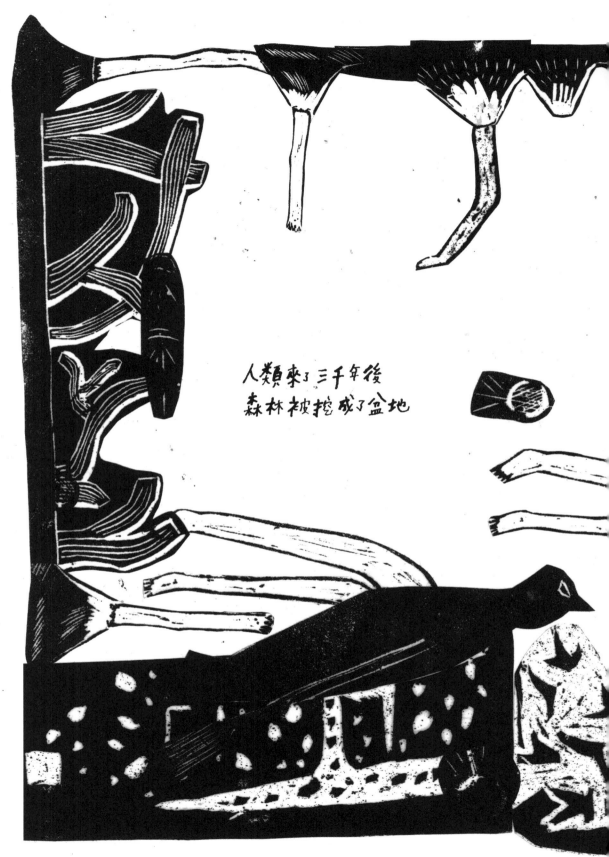

人類來了三千年後
森林被挖成了盆地

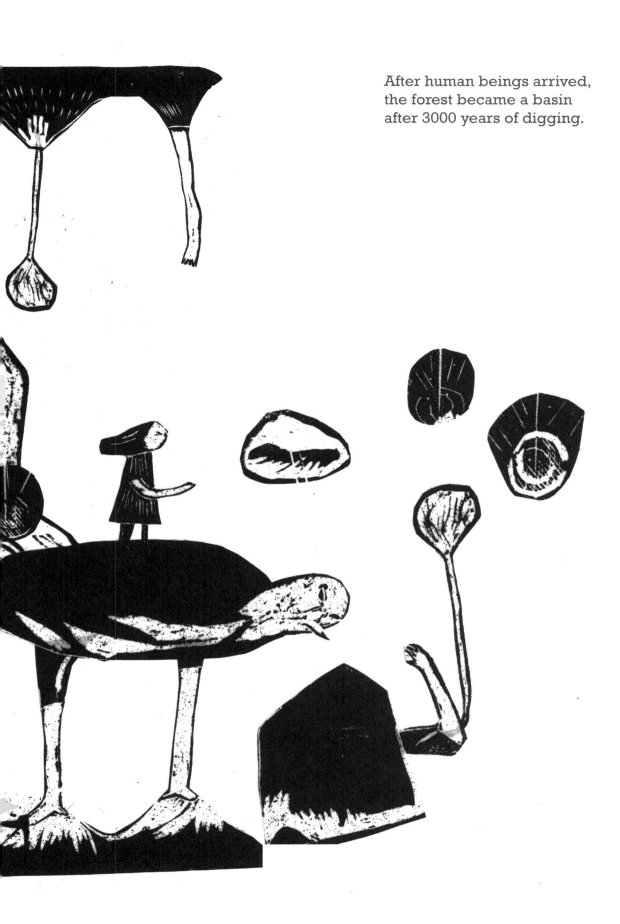

After human beings arrived,
the forest became a basin
after 3000 years of digging.

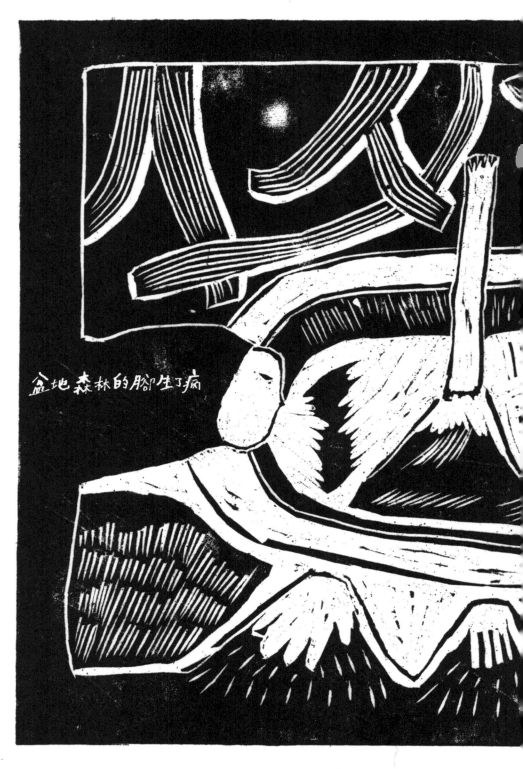

盆地森林的腳生了病

盆地森林的手斷了 盆地森林的狗被抓走了

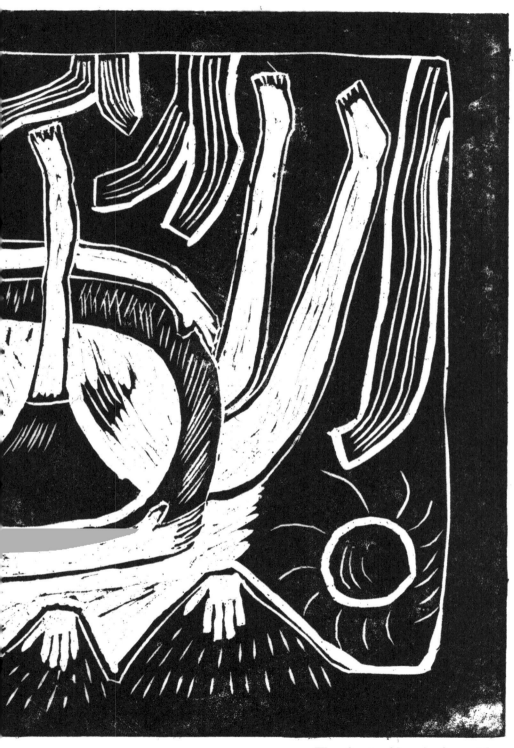

The feet of basin forest became ill.
The arms of basin forest were broken.
The dogs of basin forest were taken away.

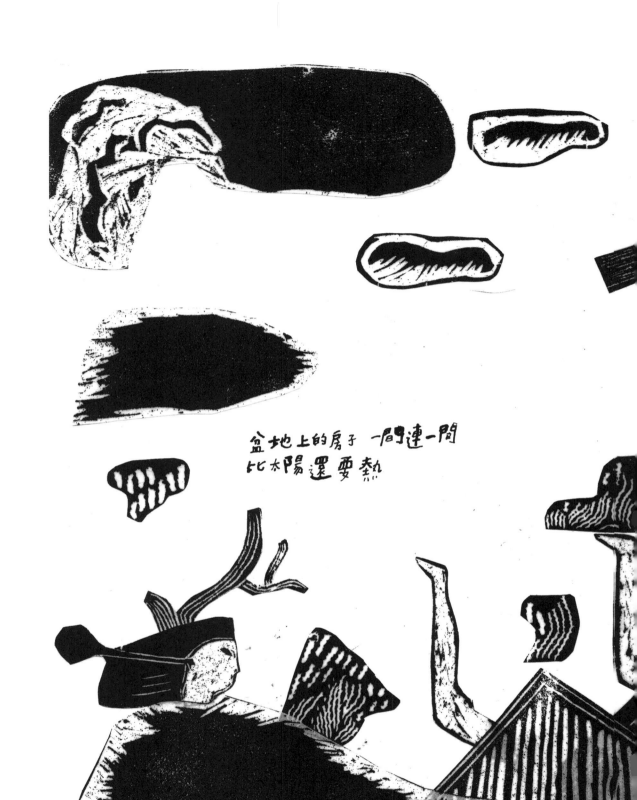

盆地上的房子 一間連一間
比太陽還要熱

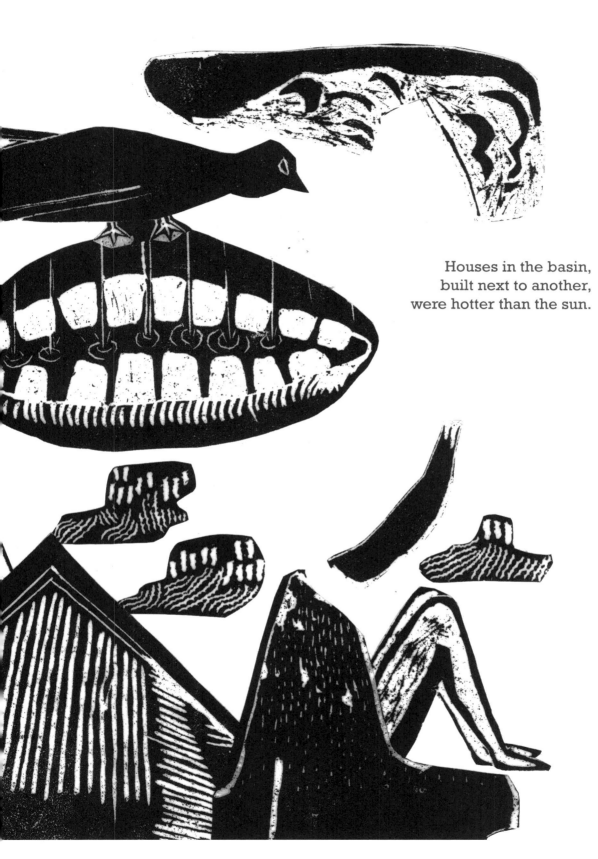

Houses in the basin,
built next to another,
were hotter than the sun.

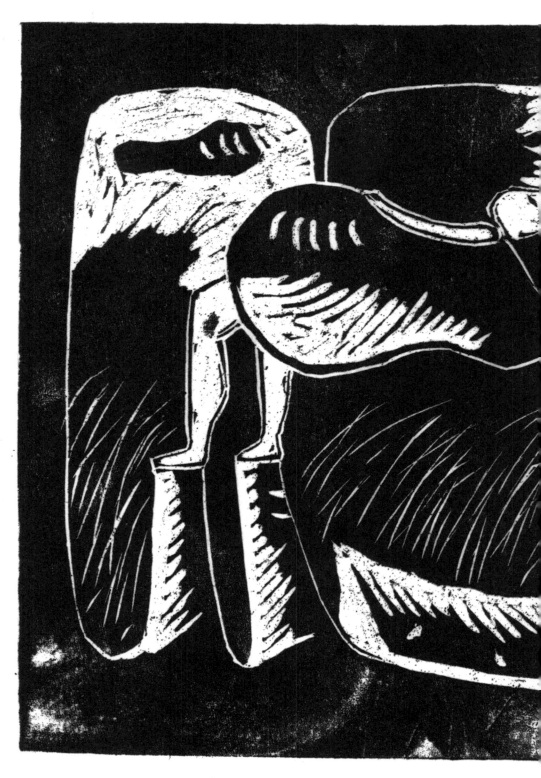

盆地太太 是後來才來的

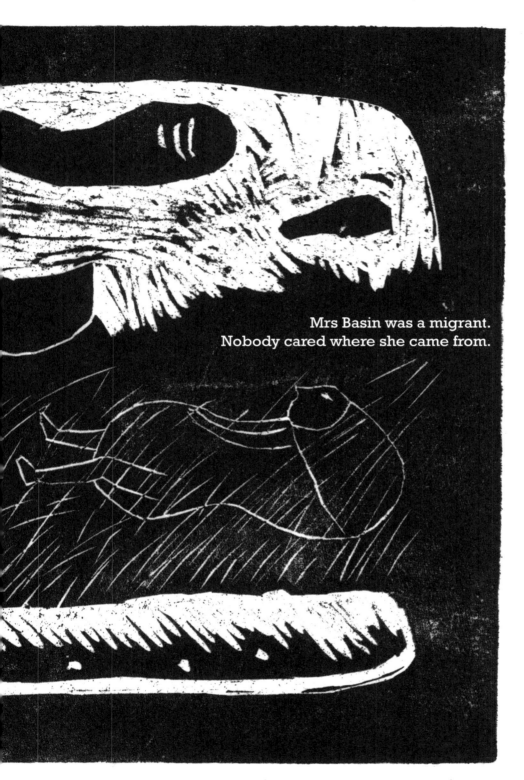

Mrs Basin was a migrant.
Nobody cared where she came from.

沒有人在意她從哪裡來

没有人想和她說話
没有人知道她到底會不會説話
反正她不説話久了
大家就認為她不會説話

Nobody wanted to talk to her.
Nobody knew whether she could speak.
Regardless, since she hasn't spoken for a long time,
People thought that she could not speak.

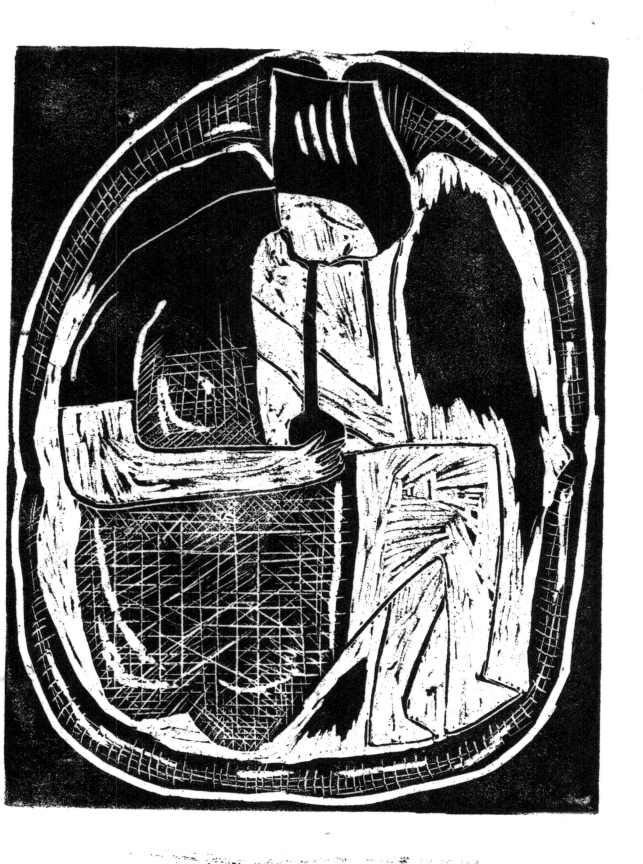

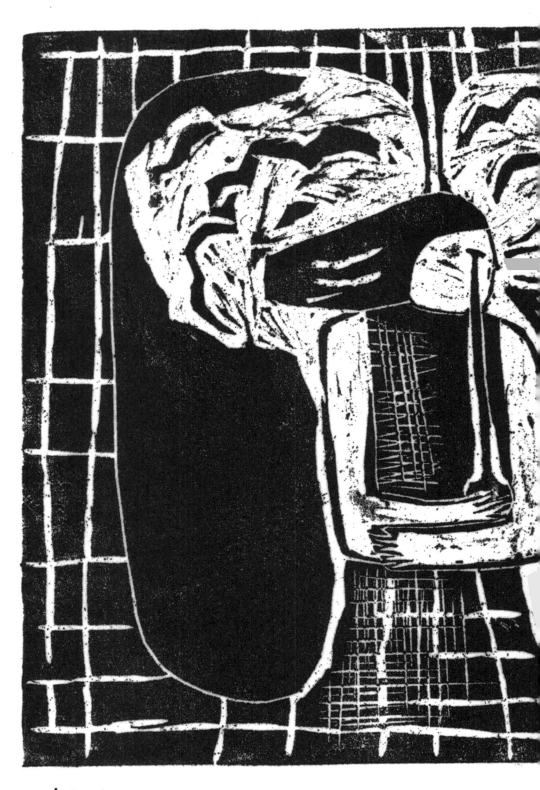

或者如她不會說盆地話 大家就沒法和她說話

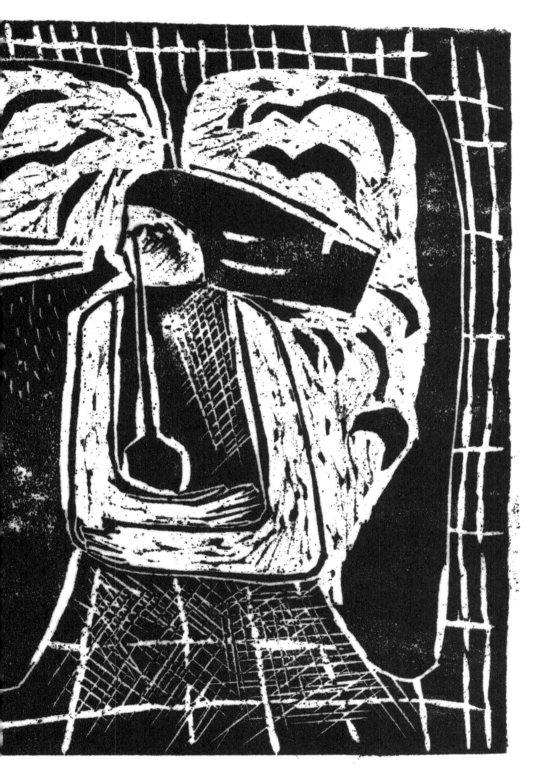

Perhaps she could not speak the language of the basin,
and nobody could talk with her.

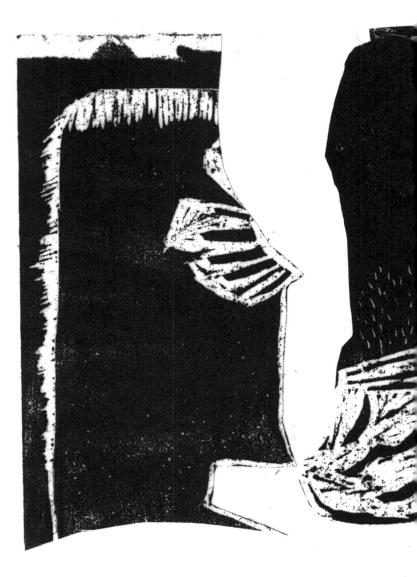

盆地林的臉
臉上許許多多的河

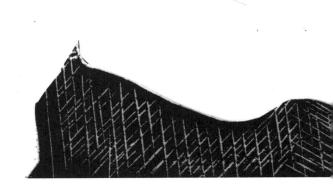

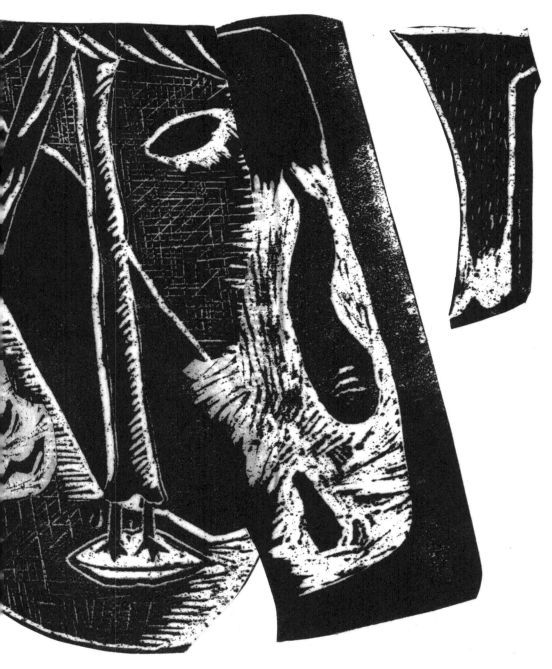

On the face of Mrs Basin,
lay many, many rivers.

就這樣一天又一天
一年又一年

Time ticked away day by day,
year by year.

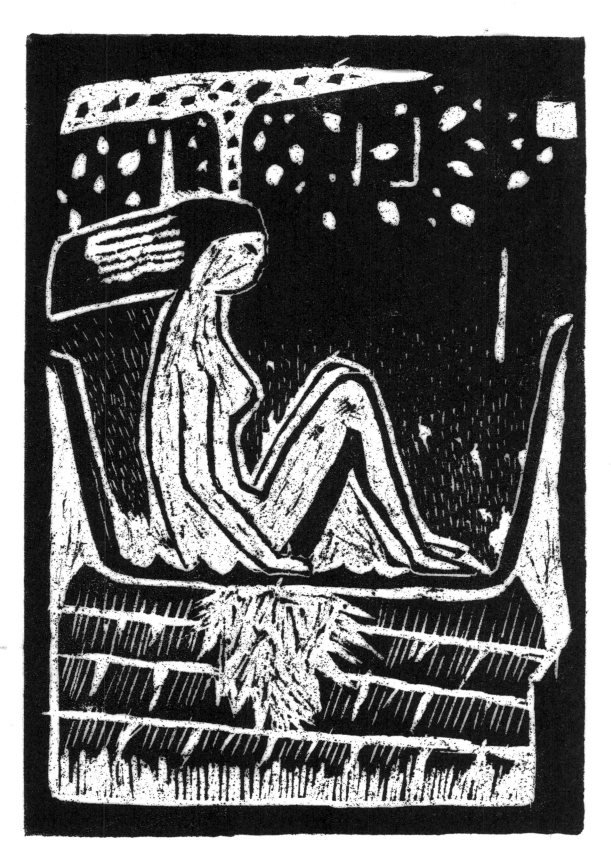

盆地太太的時間
漸漸走路不穩

Mrs Basin's time
gradually became unsteady walking.

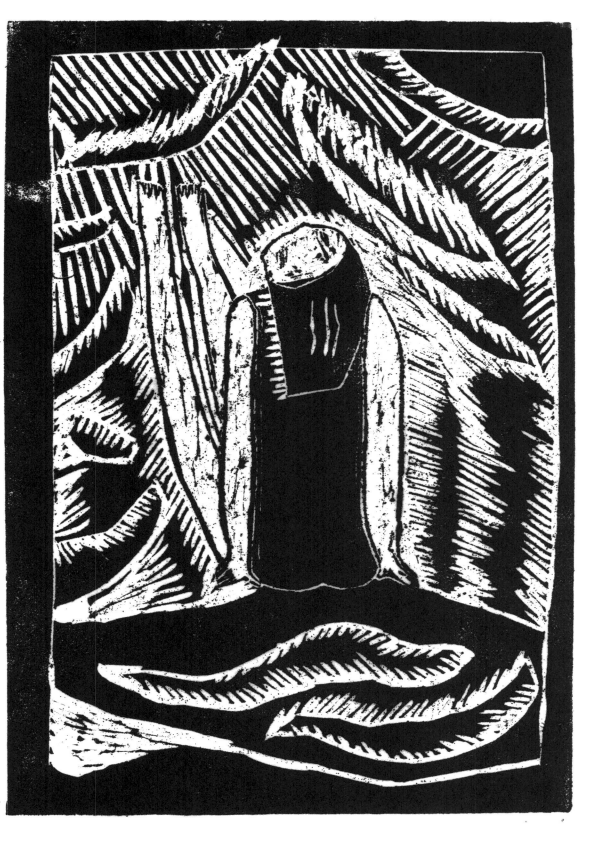

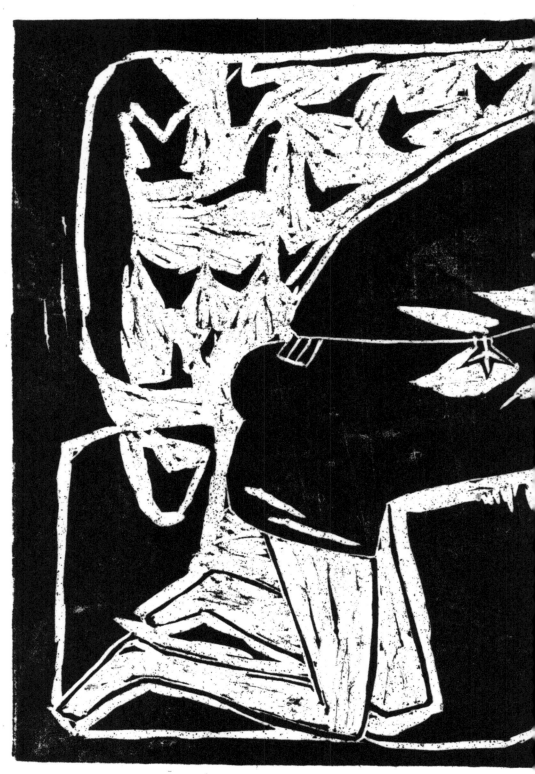

盆地太太的耳朵起床　被盆地的噪音絆倒

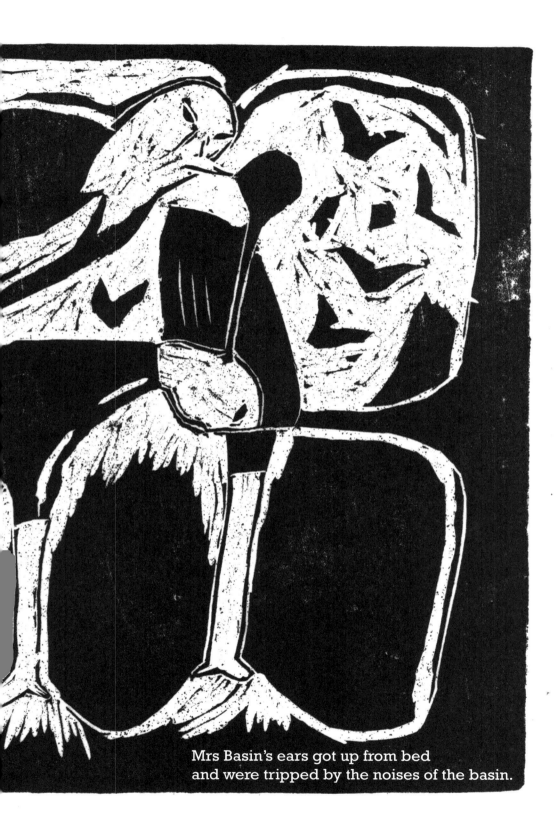

Mrs Basin's ears got up from bed
and were tripped by the noises of the basin.

盆地太太的馬尾
　　變白了　　鬆開了

Mrs Basin's ponytail
became grey
and was set loose.

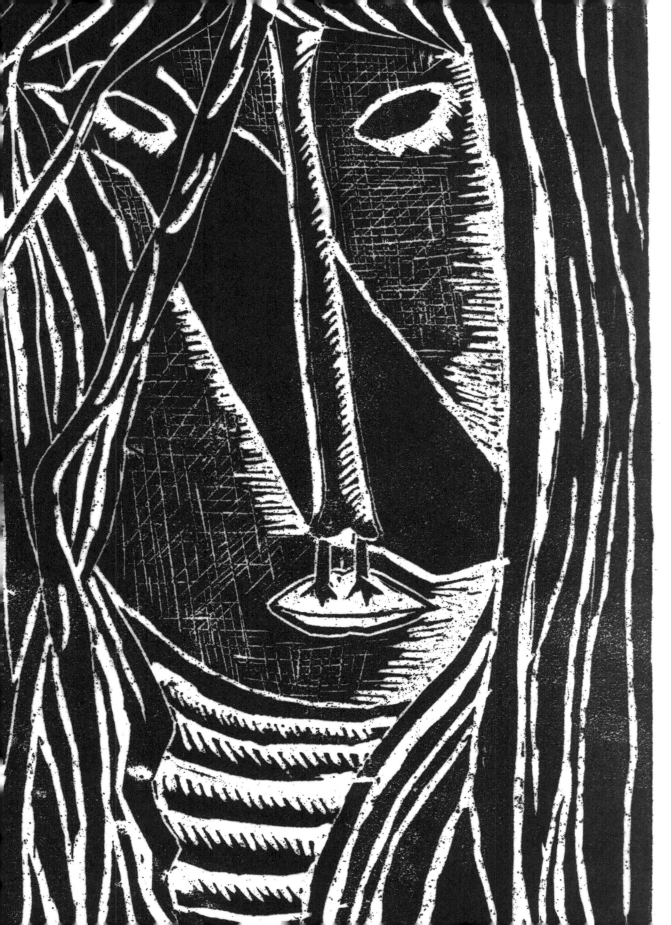

偶爾 偶爾
才有金黃金黃的太陽

盆地太太的手
摸不到那些

Occasionally, only occasionally
was there a golden shining sun.
Mrs Basin's hands
could not touch these.

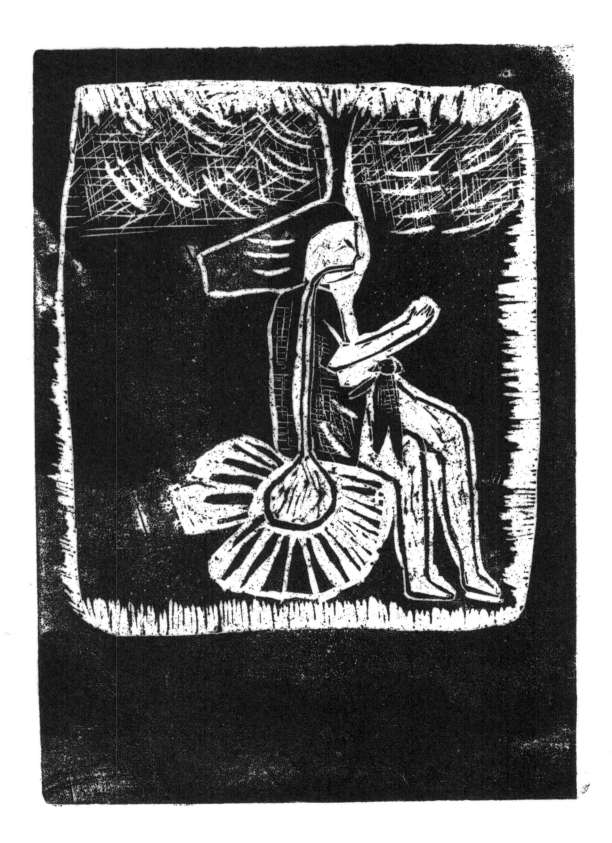

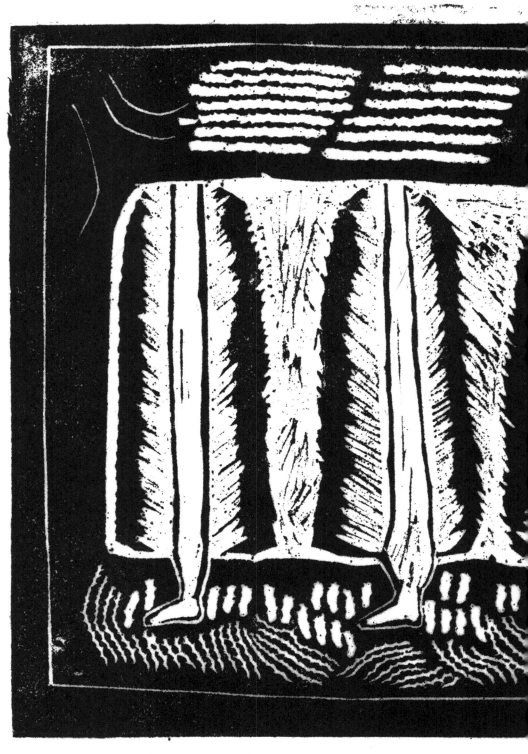

盆地太太的身體　盆地太太的雙眼　漸漸走路不穩

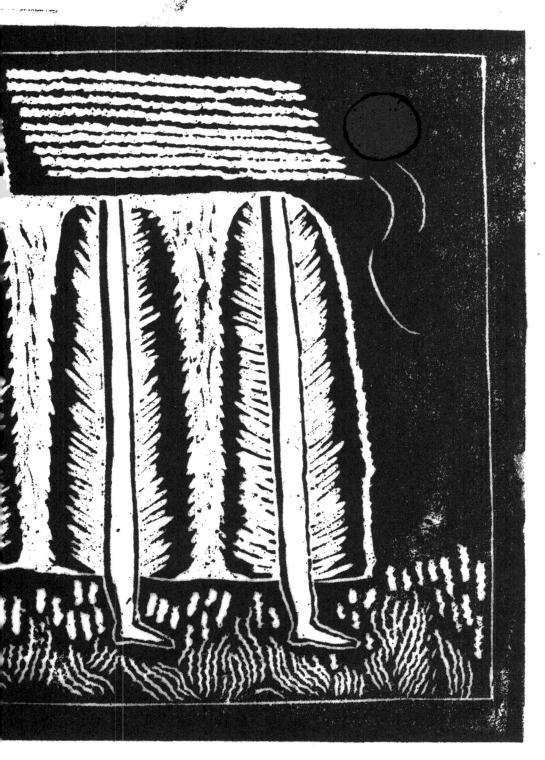

Mrs Basin's body
Mrs Basin's eyes
gradually became unsteady walking.

盆地太太決定把自己的故鄉忘記
決定在盆地老死

Mrs Basin decided to forget her hometown
She decided to die in the basin.

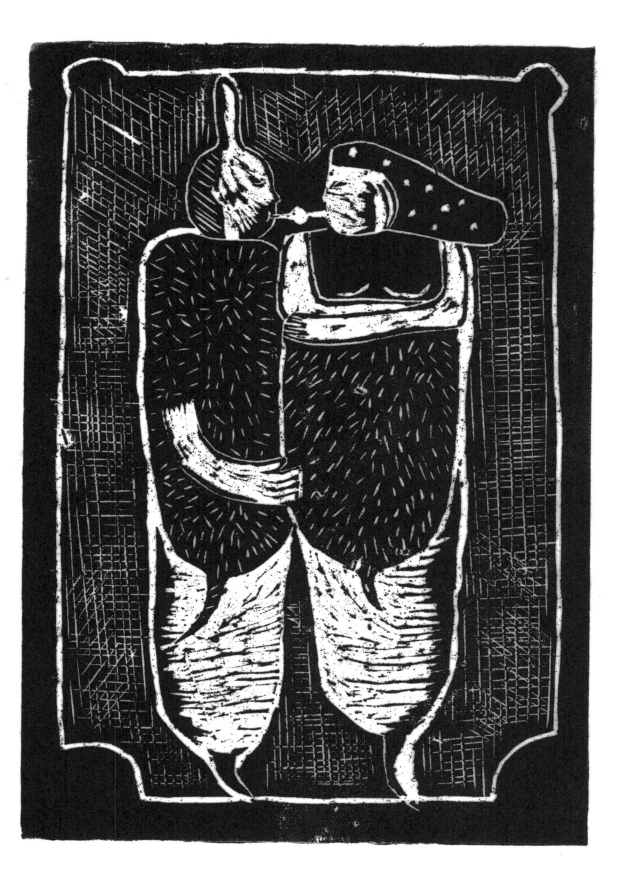

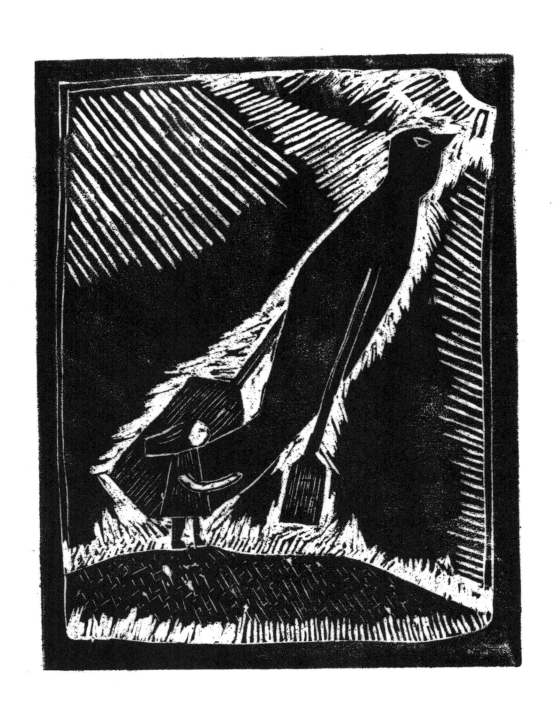

盆地太太的身體長出了野鳥
盆地太太的幽靈換上了新衣 裝上了新的臉

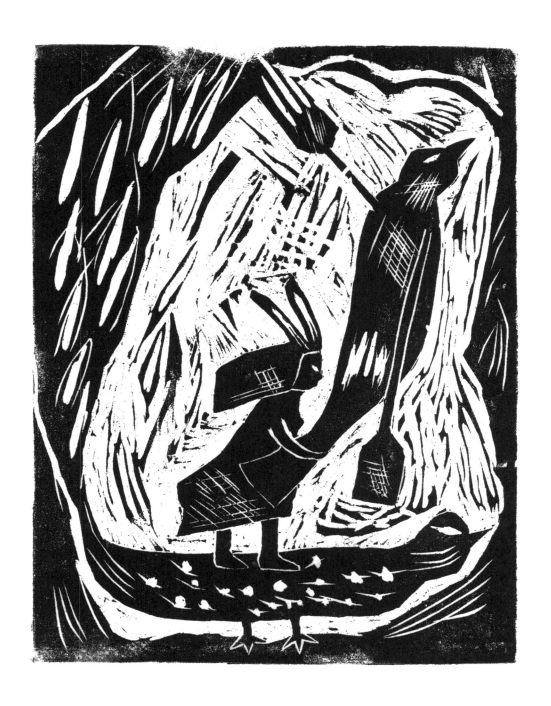

A wild bird grew from the body of Mrs Basin.
Her spirit had new clothes
and a new face was installed.

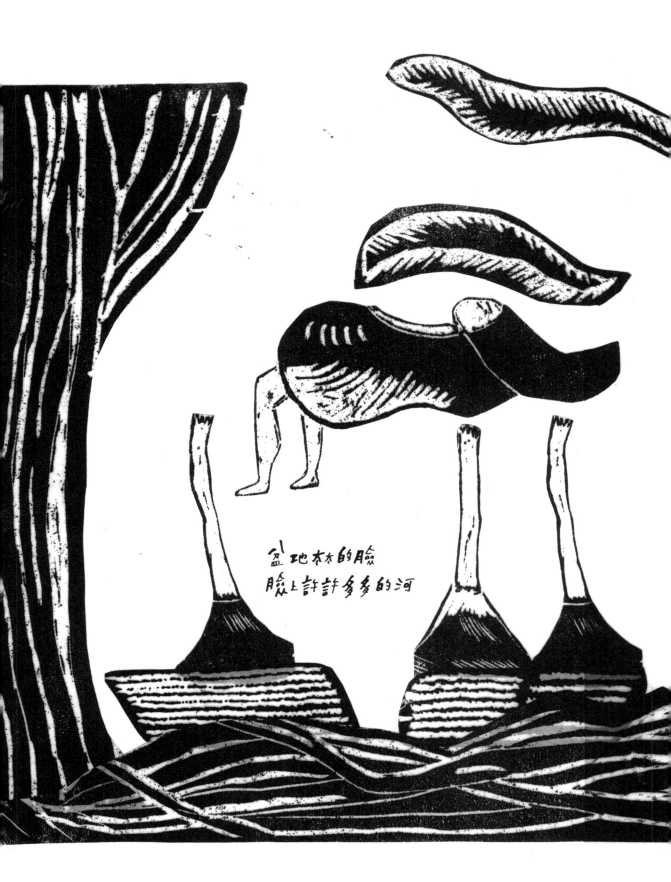

盆地太太的臉
臉上許許多多的河

On the face of Mrs Basin
lay many, many rivers.

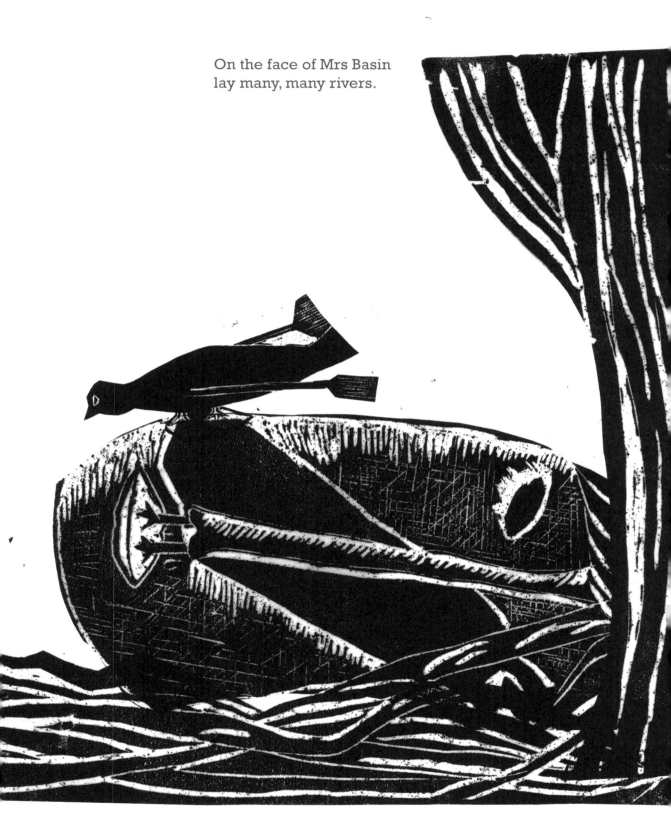

她溫順沒有發作過的憤怒
就印在這一頁紙上

The unexpressed anger which had appeared meek
is printed on this page of paper.

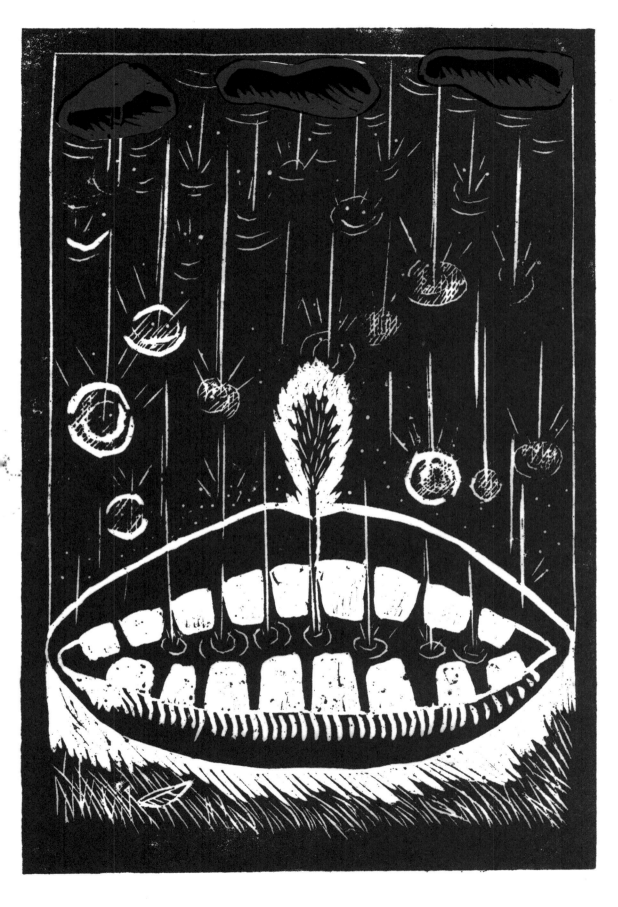

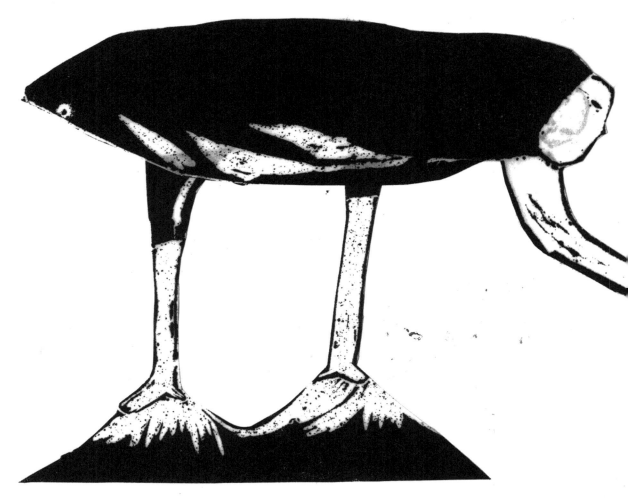

*Primo Levi，《若非此時，何時？》Se non ora, quando?，翁海貞譯，頁 19
from *Se non ora, quando?*(If not now, when?) by Primo Levi

活著的時候，一個跟另一個吃得一樣多，
死了後，一個跟另一個一樣臭。*

"One man doesn't eat more than another
when he's alive, and he stinks no worse
than another when he's dead." *

乳
房
森
林.

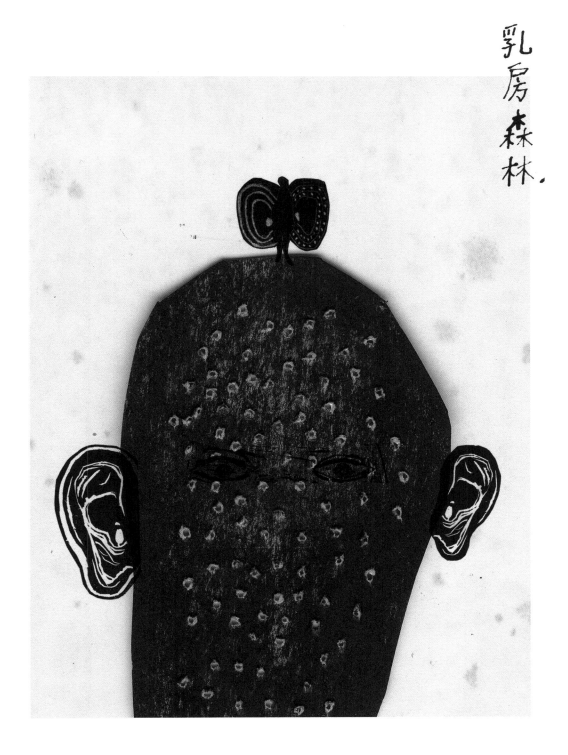

當然，消失的東西很多。
被淹沒的東西很多。
我再也不討厭消失。
那抗拒的衰老終要盛開。

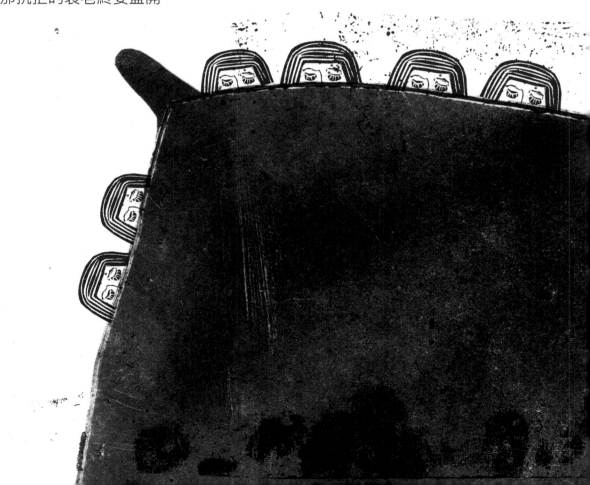

Surely, so many things have disappeared.
So many things have been drowned.
I no longer hate disappearance.
Though resisted, aging will surely bloom.

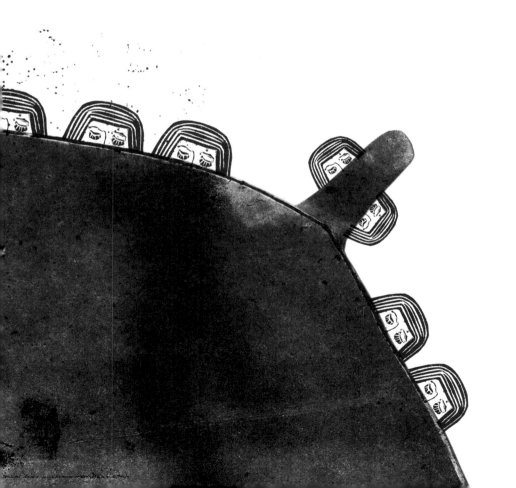

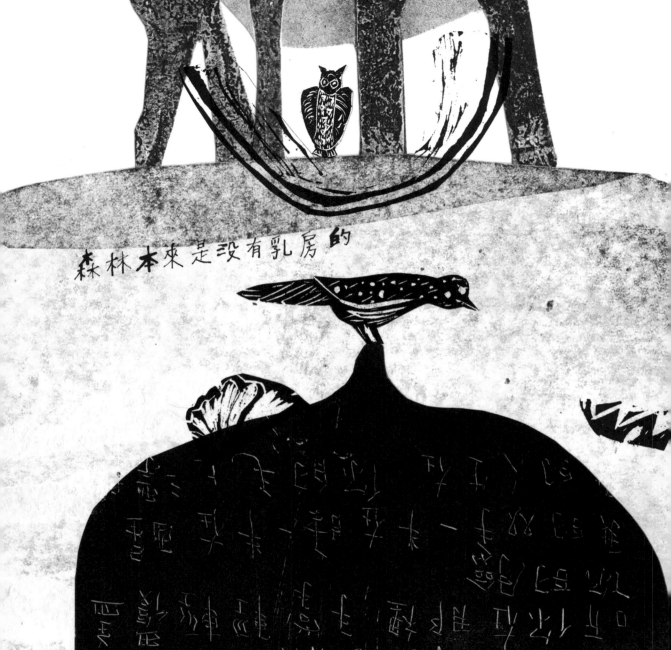

森林本來是沒有乳房的

The forest had no breast

Let me stretch upon the
let me hear the
street knowing I'm safe
inside blankets, wrapped and
drifting off to sleep

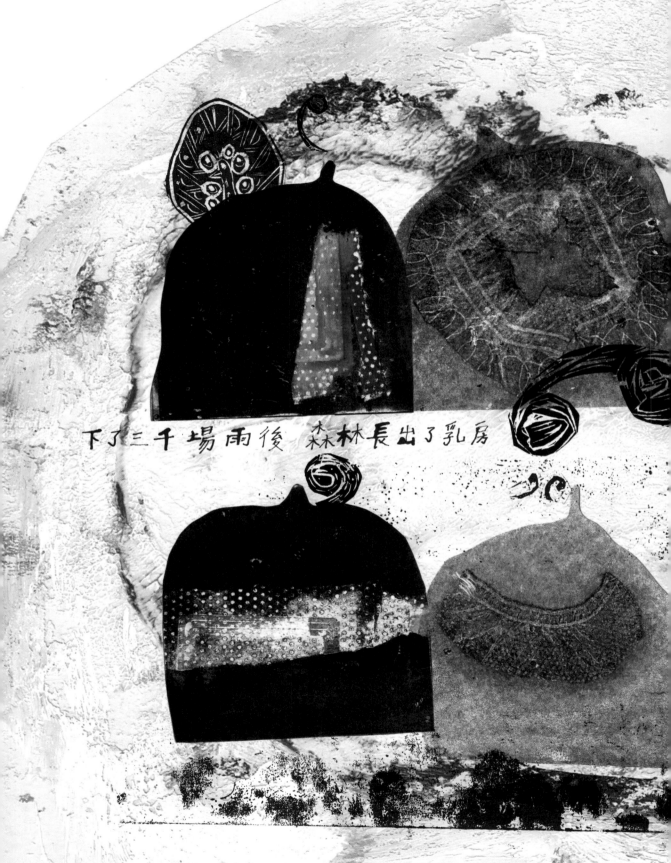

下了三千場雨後　森林長出了乳房

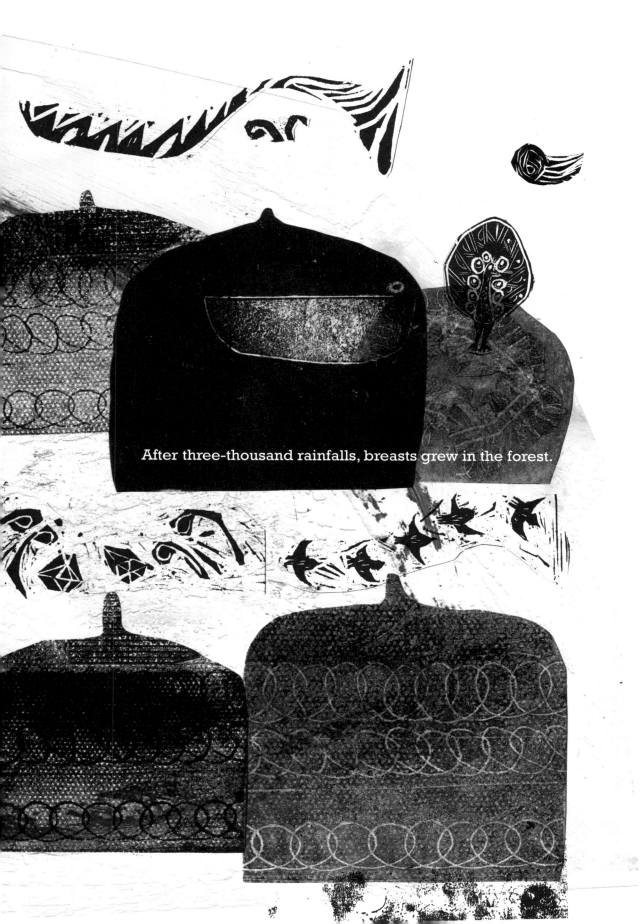

After three-thousand rainfalls, breasts grew in the forest.

森林本來是沒有耳朵的

The forest had no ear

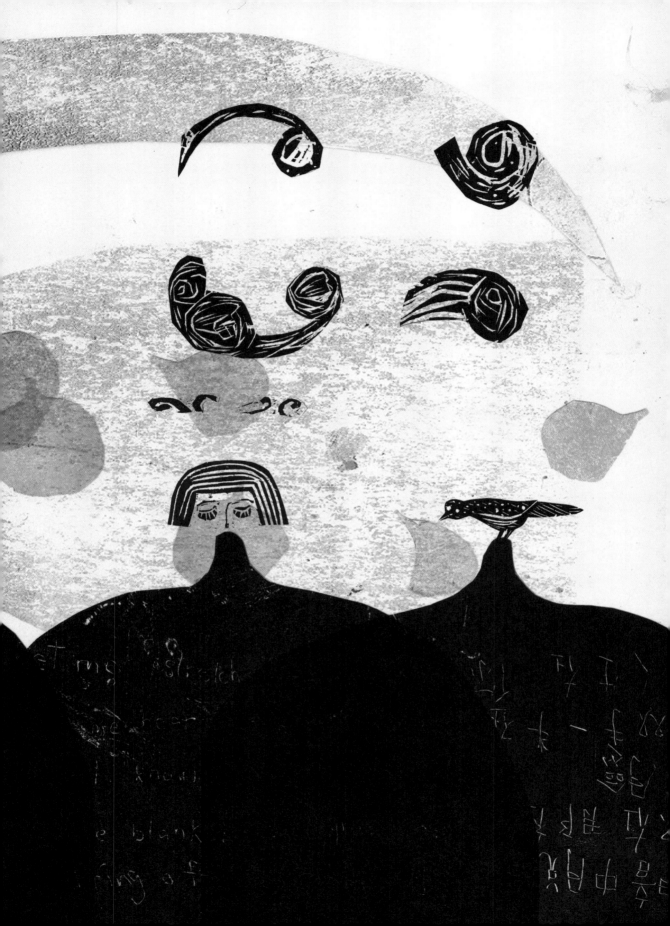

下了三千場雨後森林長出了耳朵

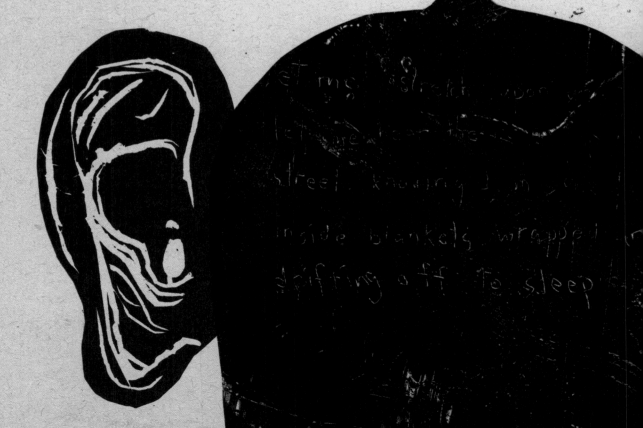

After three-thousand rainfalls, ears grew in the forest.

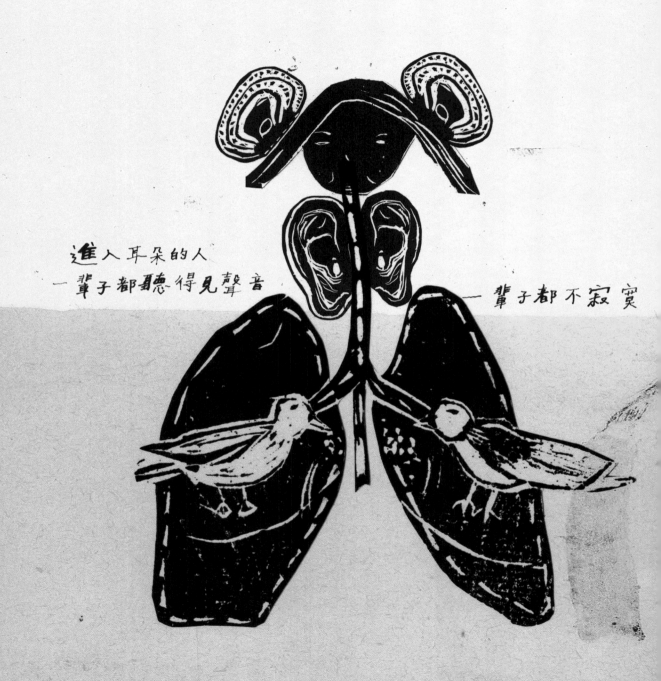

進入耳朵的人
一輩子都聽得見聲音

一輩子都不寂寞

Those who entered the ears heard sounds for a lifetime.

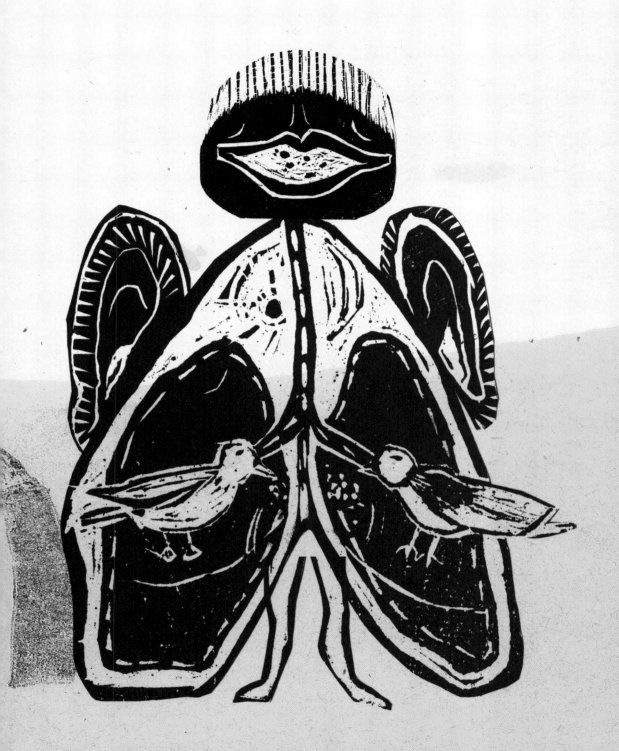

Never to be lonely again.

進入乳房的人變成了小孩子
一輩子都有母親

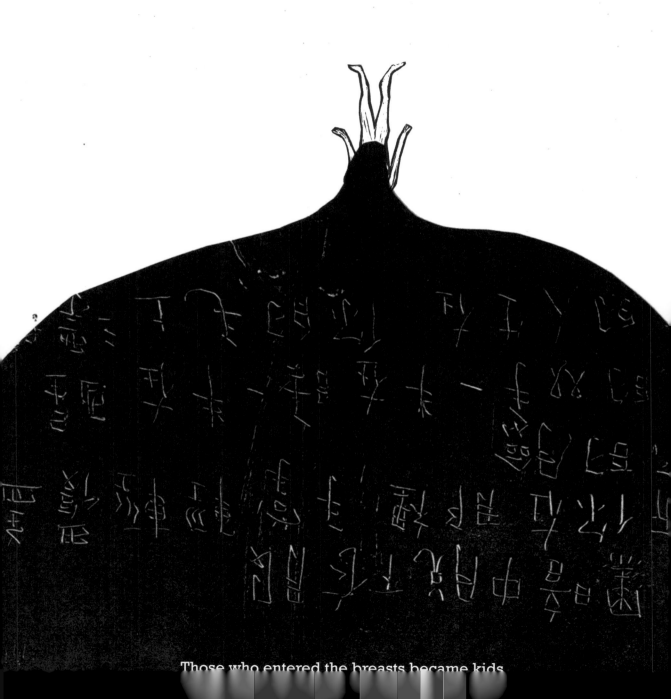

Those who entered the breasts became kids

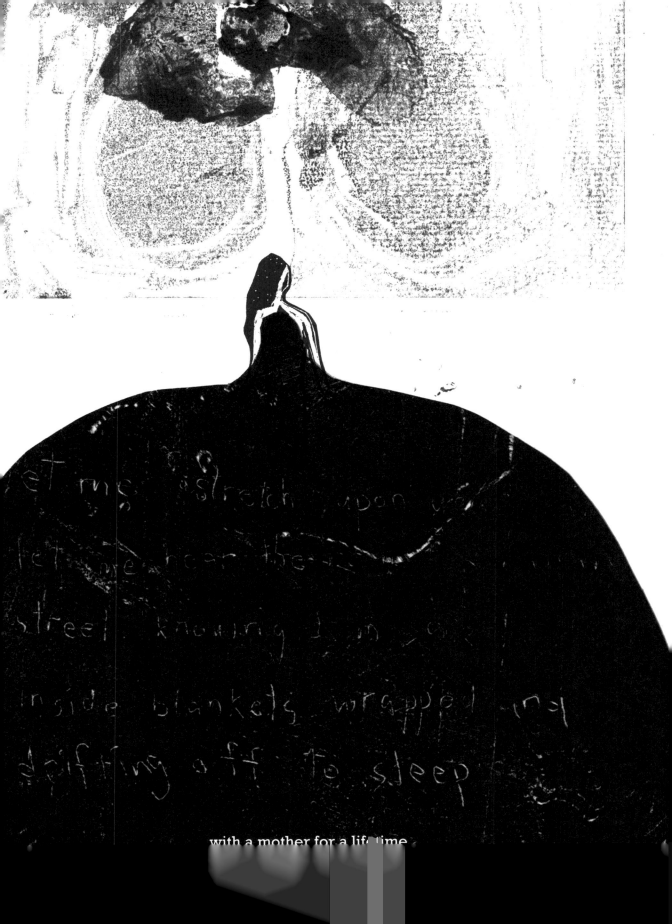

et me stretch upon

let me hear the

street knowing I'm so

inside blankets wrapped and

drifting off to sleep

with a mother for a life time

日日夜夜
都有人排隊想進入乳房

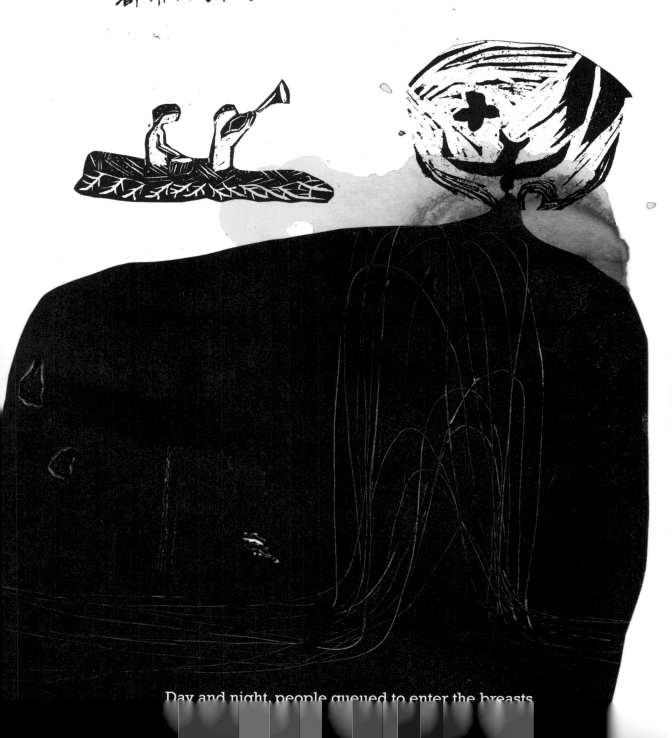

Day and night, people queued to enter the breasts.

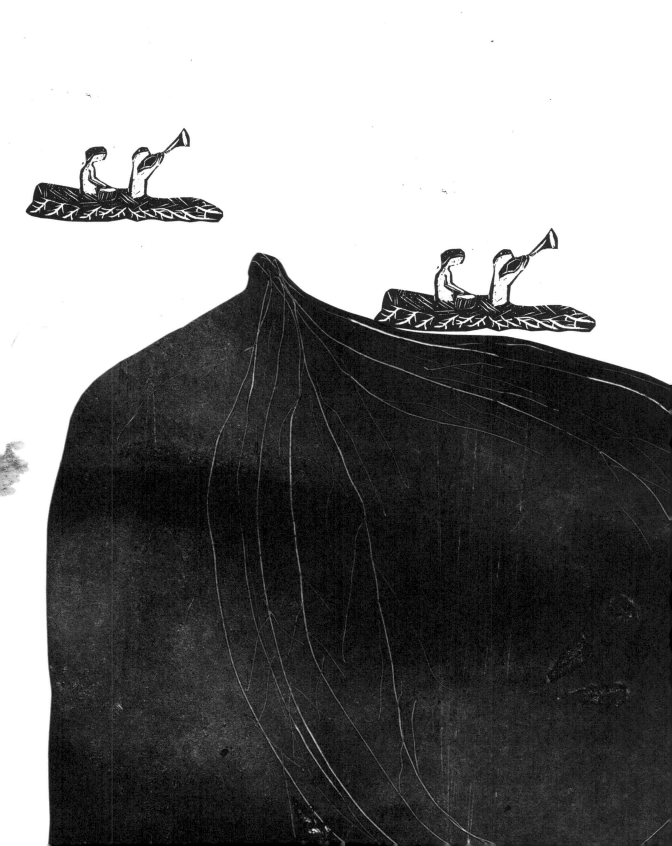

夜夜 日日
都有人排隊想進入耳朵

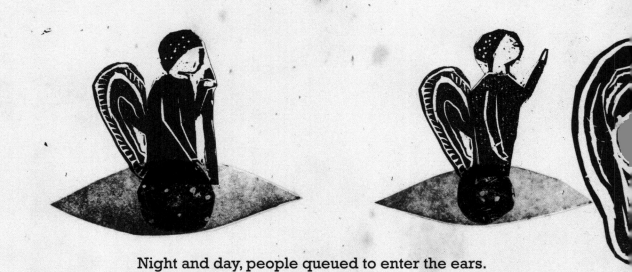

Night and day, people queued to enter the ears.

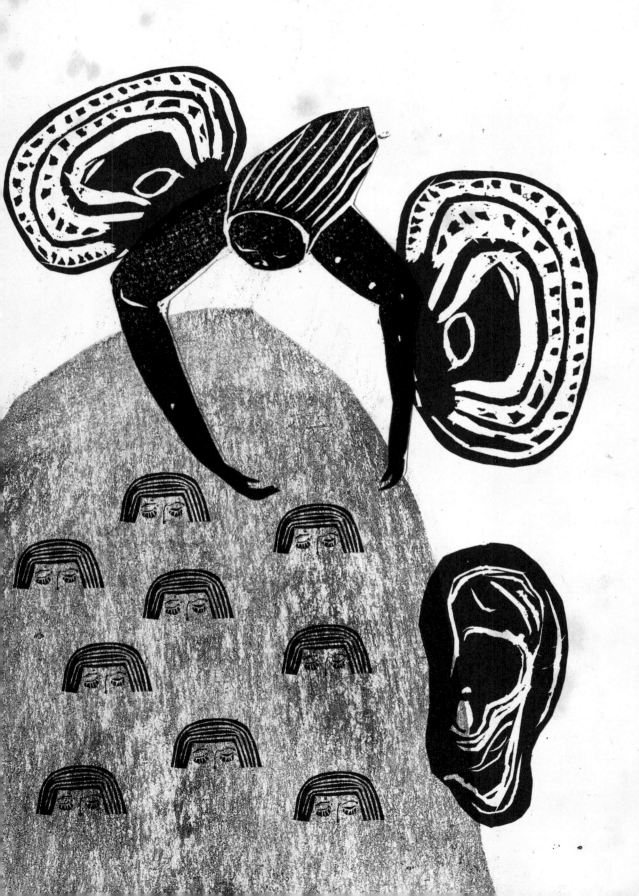

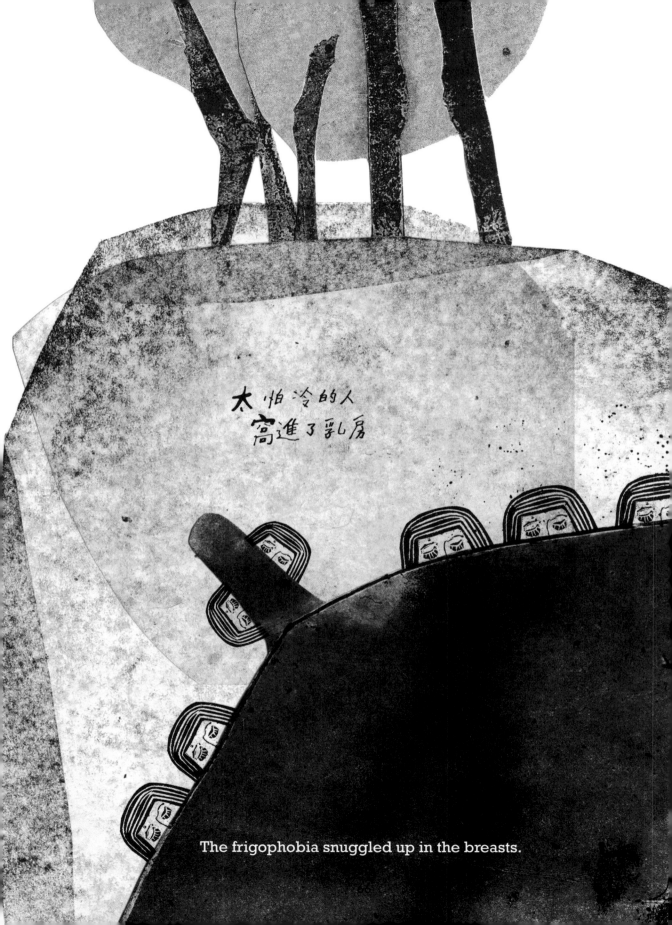

太 怕冷的人
窩進了乳房

The frigophobia snuggled up in the breasts.

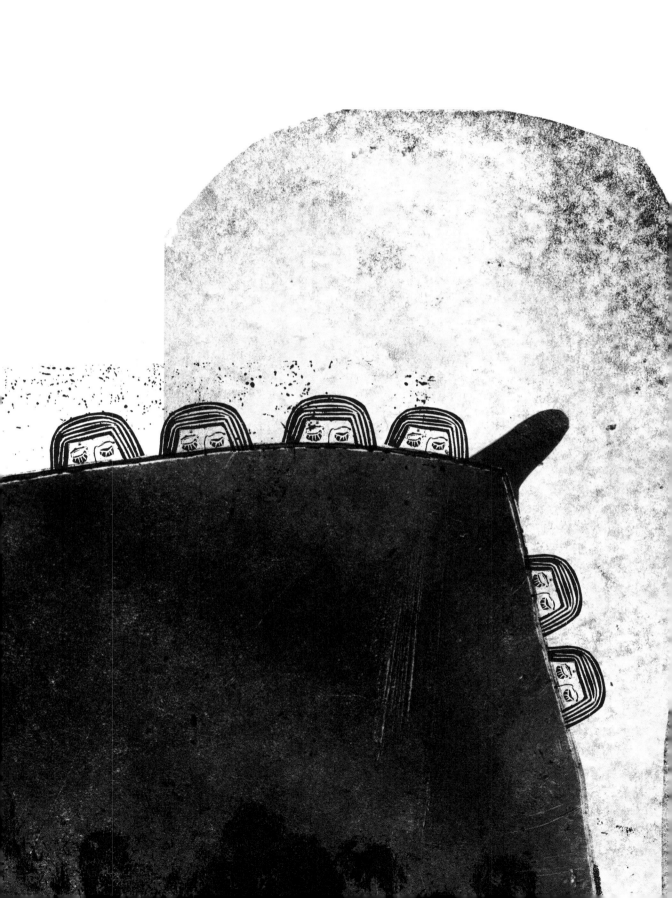

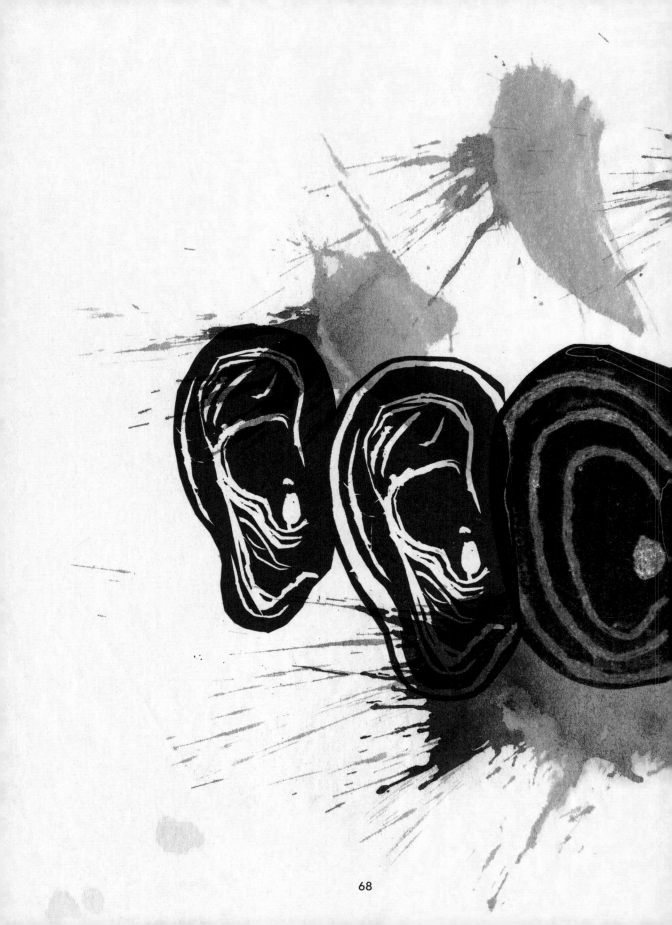

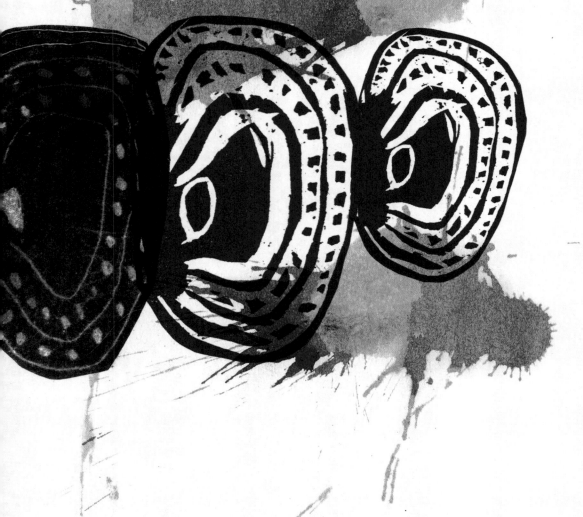

Wiggled into the ears.

太害怕寂寞的人
全身長滿了耳朵

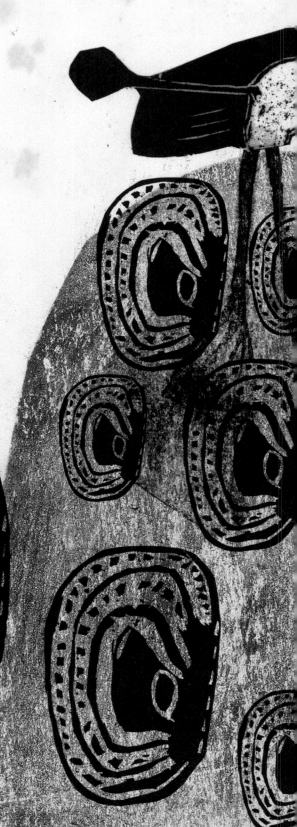

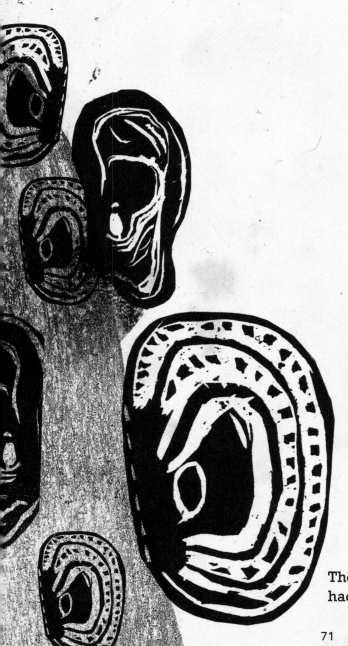

Those fearing loneliness too much
had ears sprouting all over the body.

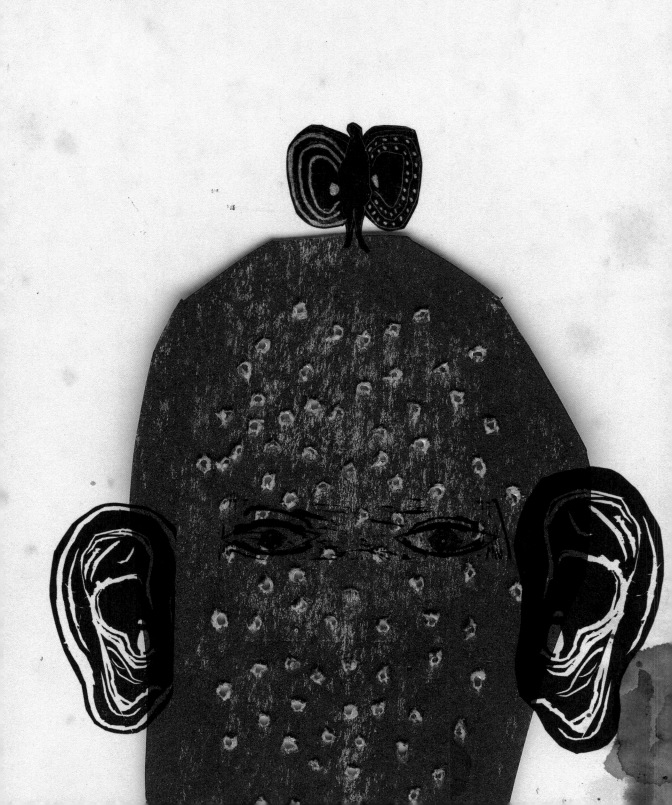

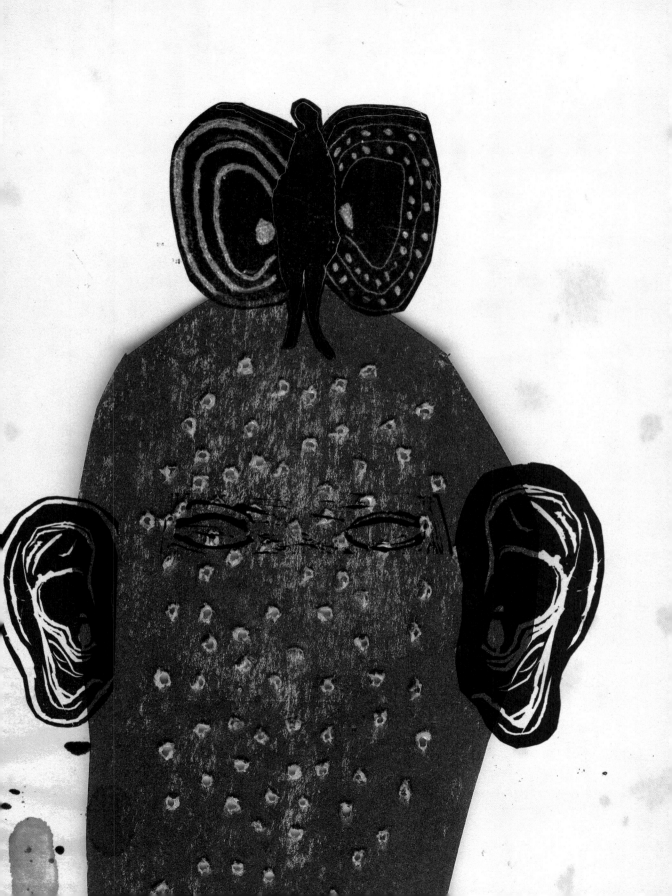

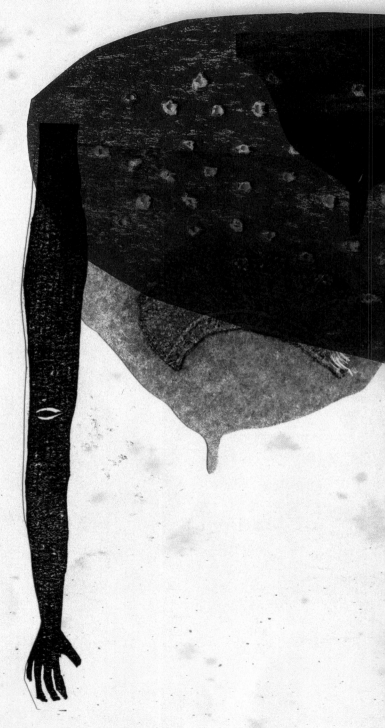

太需要母親的人
全身長滿了乳房

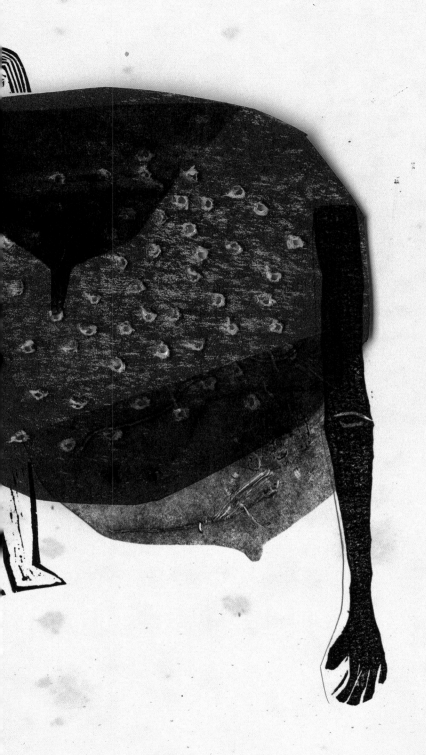

Those yearning too much for a mother
had breasts sprouting all over the body.

直到春風吹起
夏日歸來

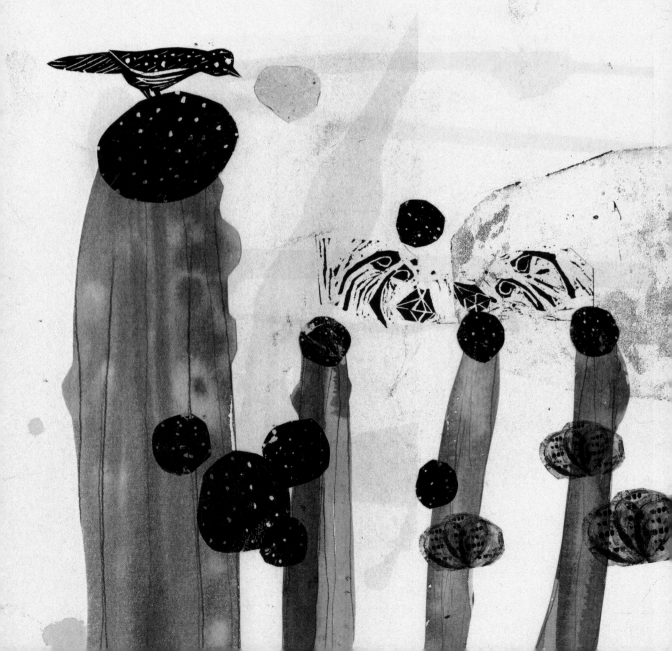

Then the spring breeze waltzed
and the summer sun returned.

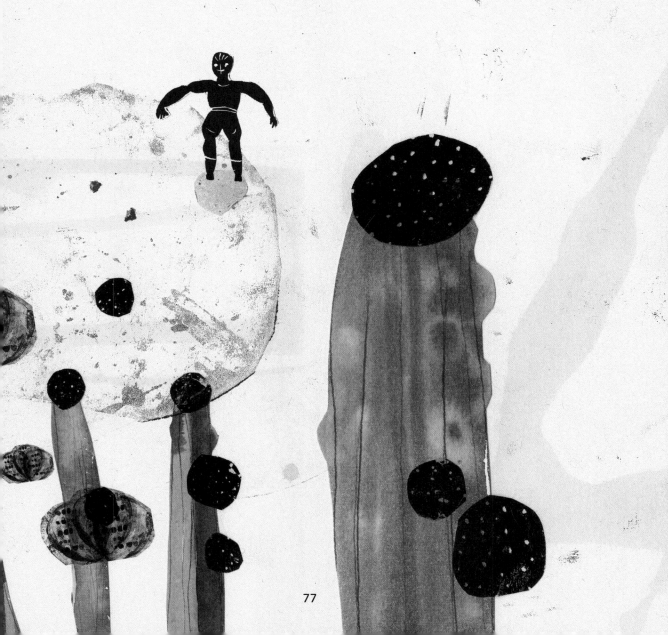

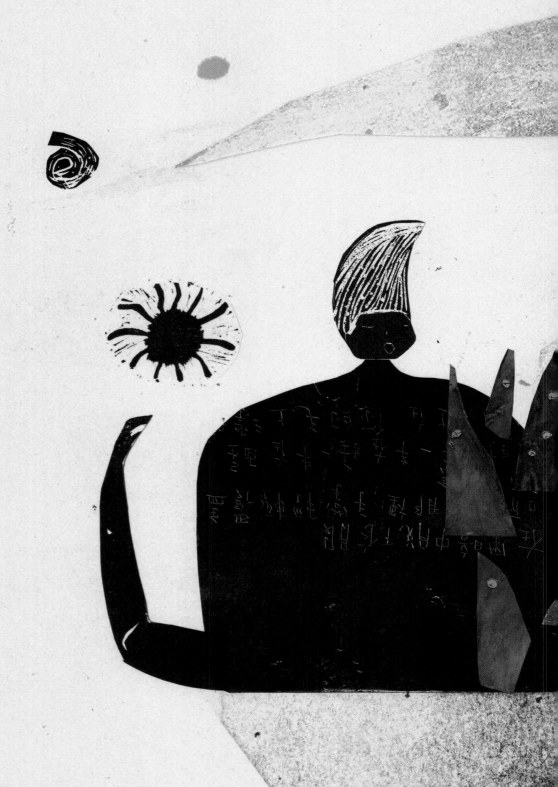

The forest regained its look with no breast.

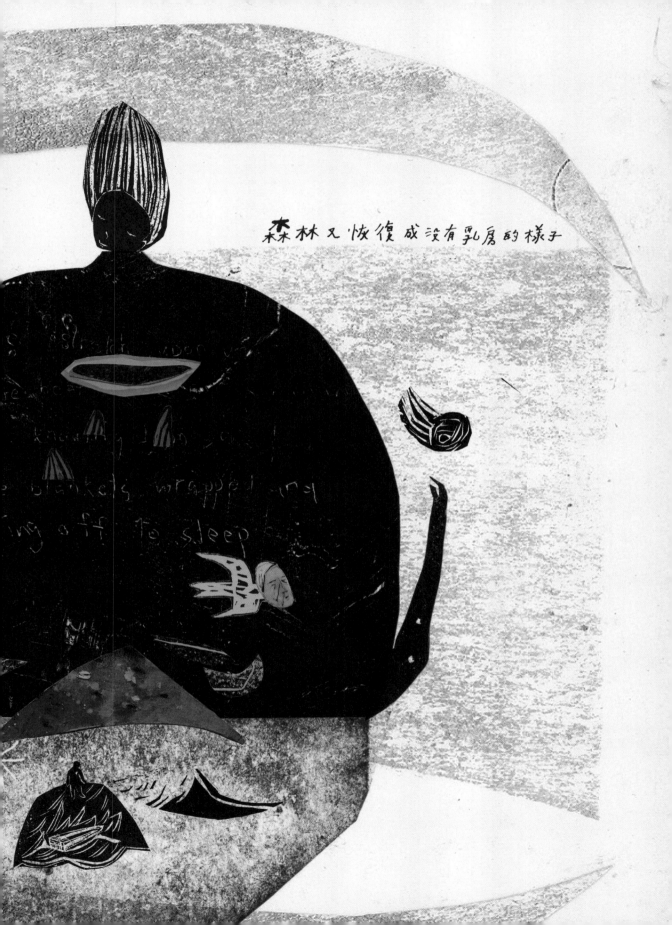

森林又恢復成沒有乳房的樣子

我也恢復成人的樣子

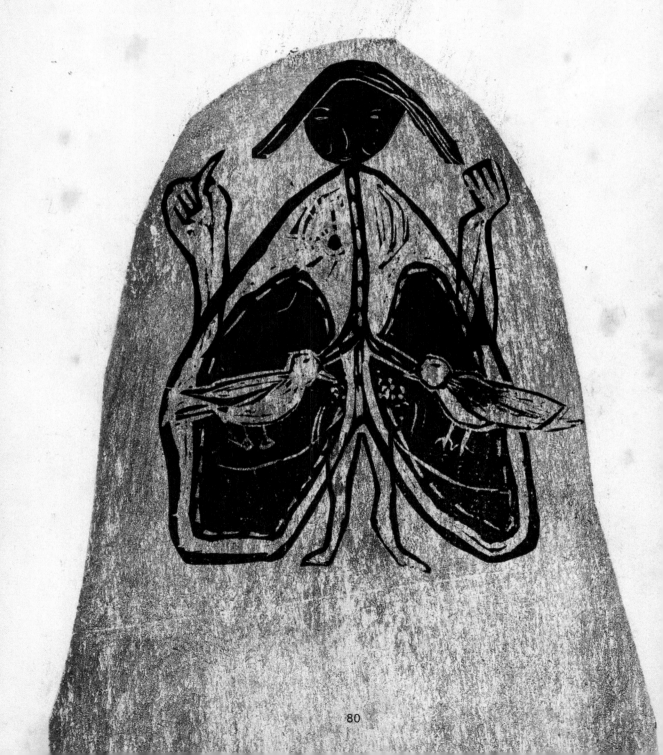

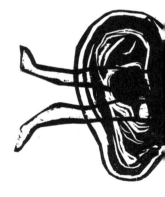

I regained the look of an adult.

以此作品獻給冬天的台北

冬天的台北，
就是一座下了三千場雨的
乳房森林、耳朵森林。

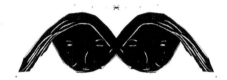

Taipei in winter is a forest of breasts and ears
after three-thousand rainfalls.

文中一再提到的「三千年」，典故出自這句話「無法對自己描述出過去三千年歷史的人，就像活在黑暗中，缺乏經驗依循，只是一天又一天地過著日子。——歌德」
轉引自蘇珊‧桑塔格＜西貝爾貝格的希特勒＞，《土星座下》，麥田出版，2007

The repeated reference of "3000 years" in Sontag's book* came from the following statement by Goethe: "Anyone who cannot give an account to oneself of the past three thousand years remains in darkness, without experience, living from day to day."
*Susan Sontag, "Syberberg's Hitler", *Under the Sign of Saturn*, Rye Field Publication, 2007

The hands which grew

會長大的手

夜裡，她的手會長大，
愈長愈大直到相片裡
那雙手看來像別人的器官
擺在她膝蓋上

〈淺談安眠石〉
Anne Carson，《淺談》short talks.

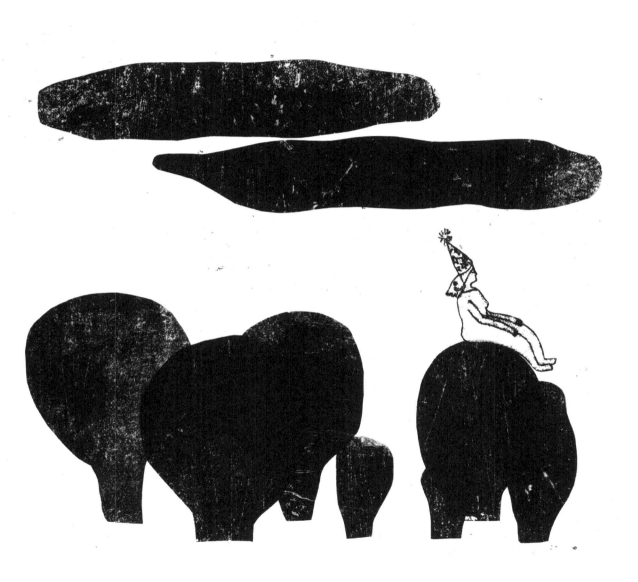

Night was when her hands grew, huger and huger
until in the photograph they are like two parts of someone else
loaded onto her knees.

Short talk on sleep stones, Anne Carson

森林本來是沒有手的

The forest had no hands.

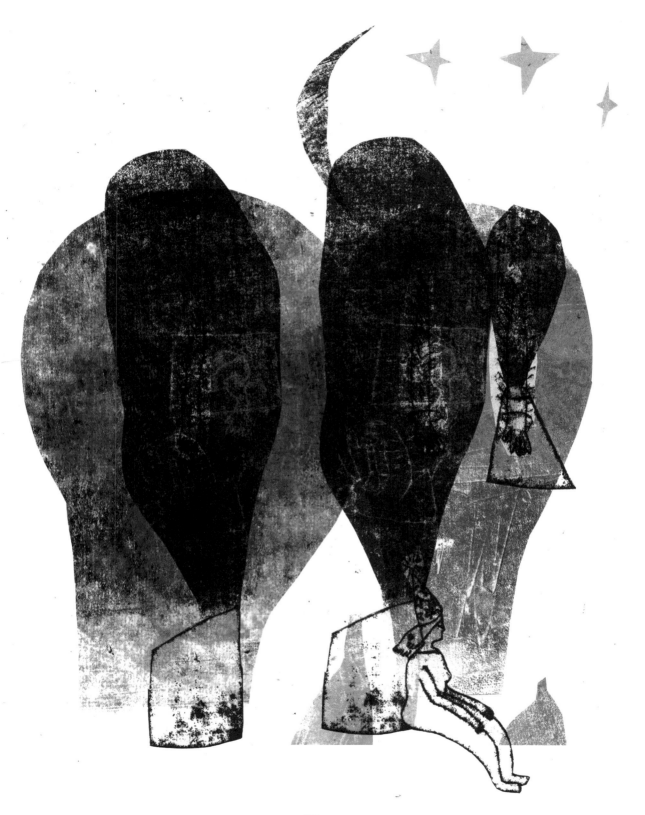

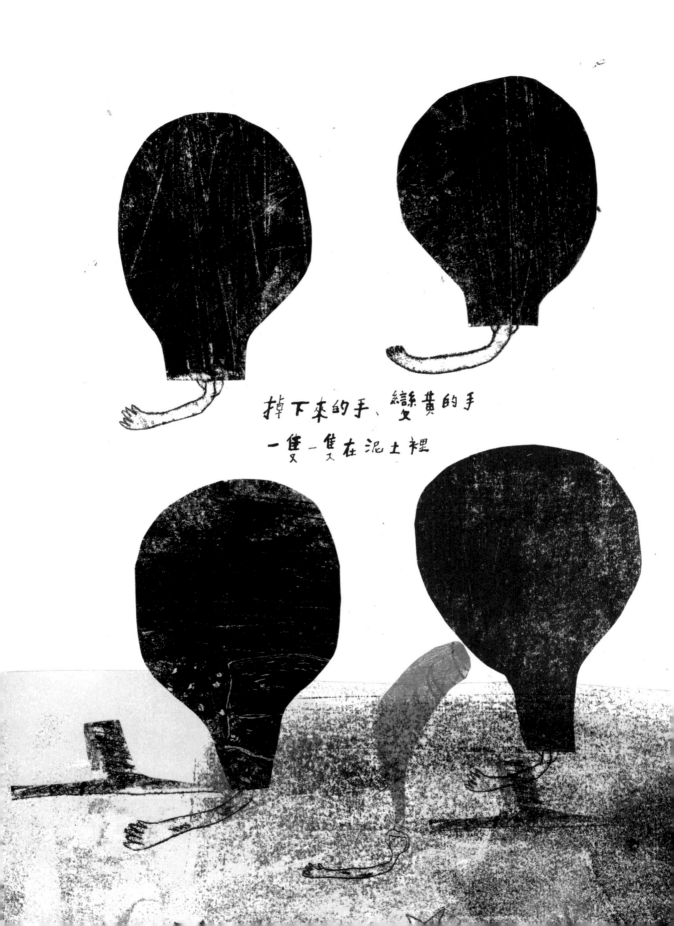

掉下來的手、變黃的手
一隻一隻在泥土裡

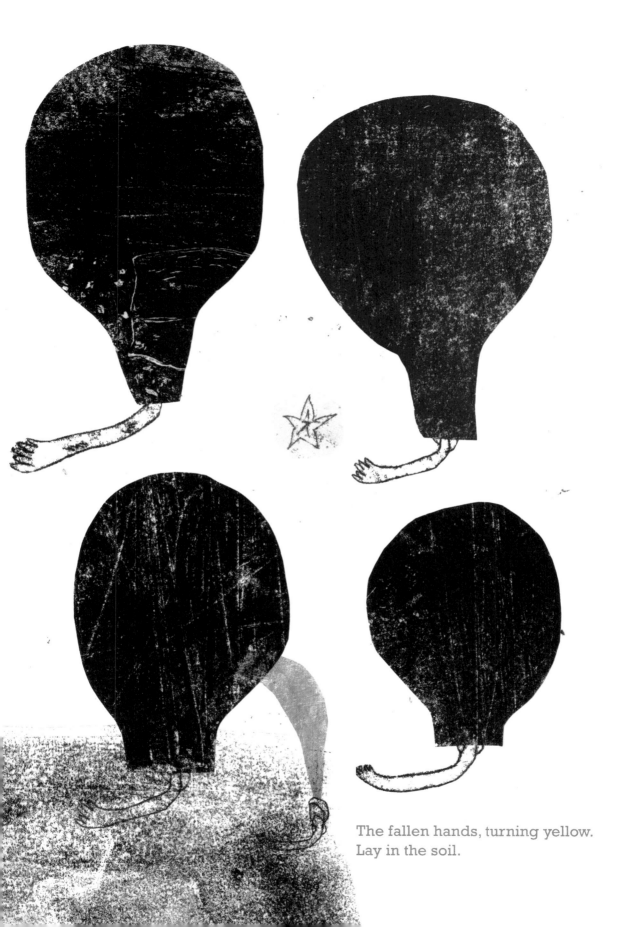

The fallen hands, turning yellow.
Lay in the soil.

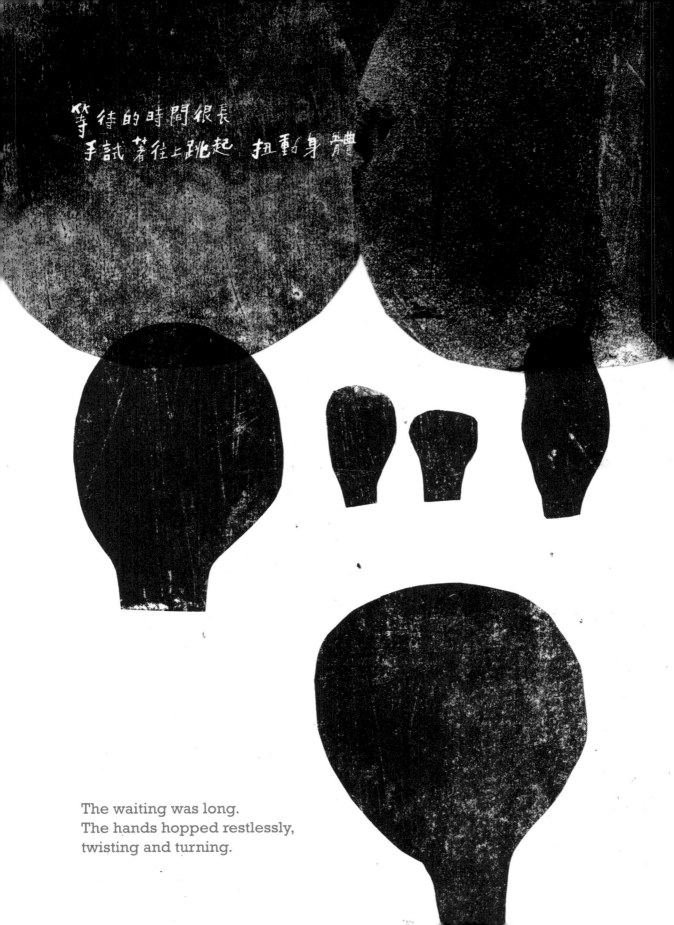

等待的時間很長
手試著往上跳起 扭動身體

The waiting was long.
The hands hopped restlessly,
twisting and turning.

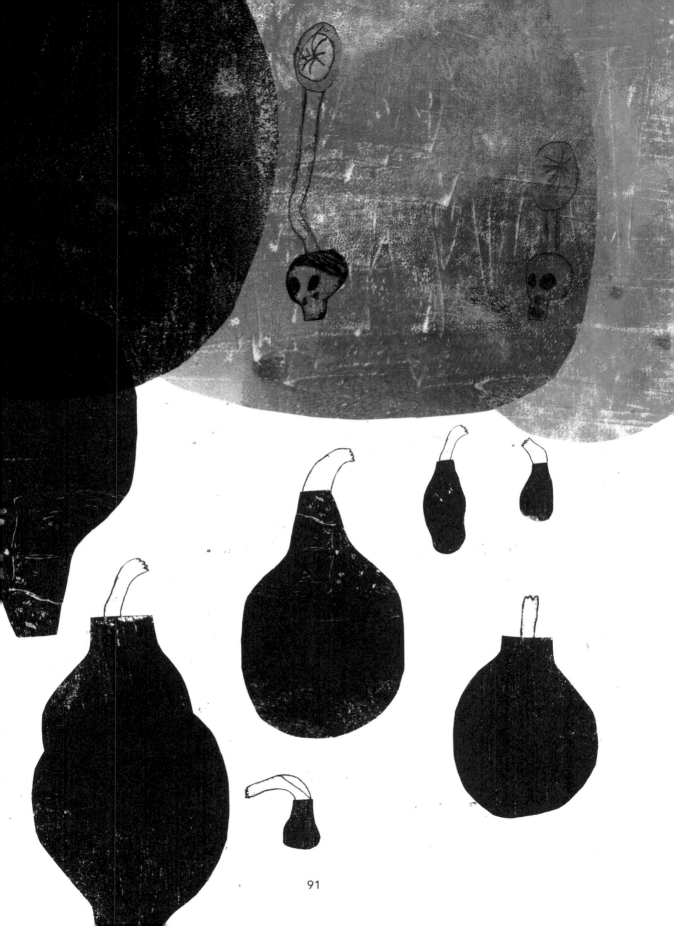

91

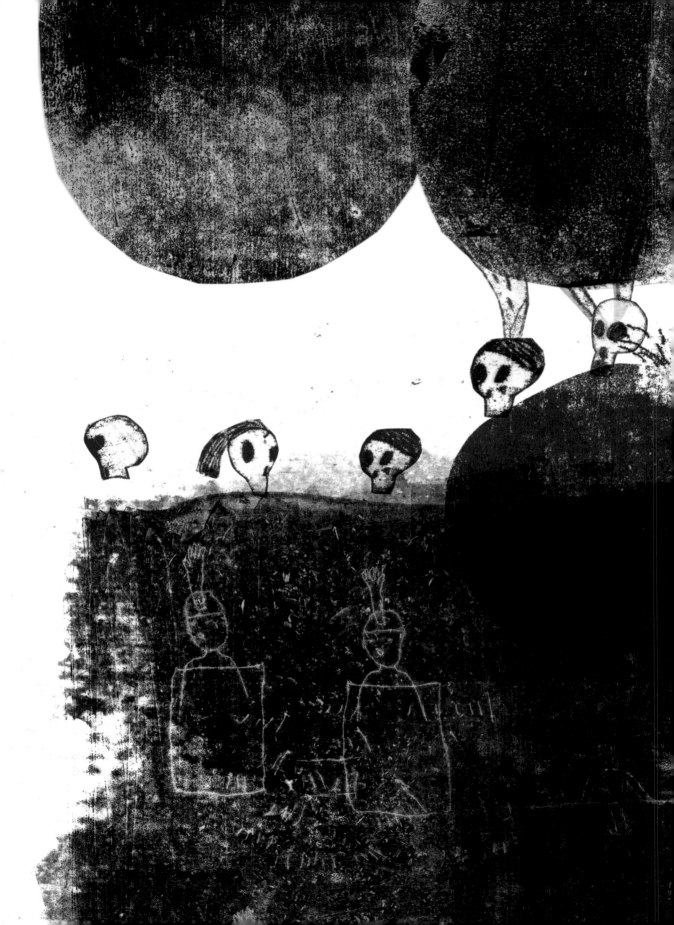

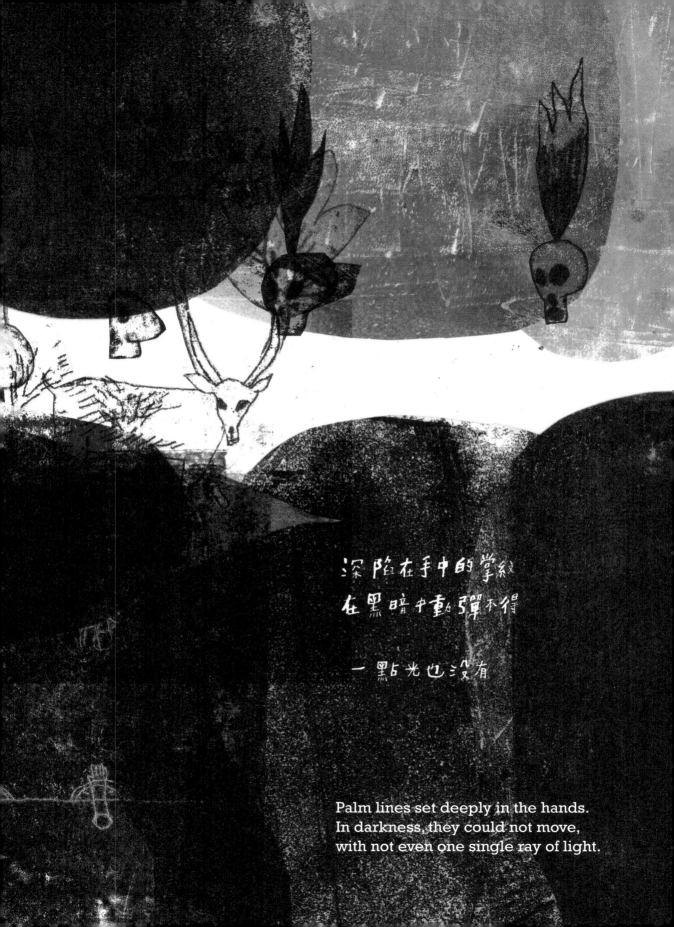

深陷在手中的掌紋
在黑暗中動彈不得

一點光也沒有

Palm lines set deeply in the hands.
In darkness, they could not move,
with not even one single ray of light.

春天
手把自己的唇貼在
漸漸溫暖的泥地上
翻出了身

Spring came.
The hands placed their lips on the warming earth,
flipped and turned around.

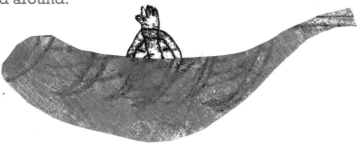

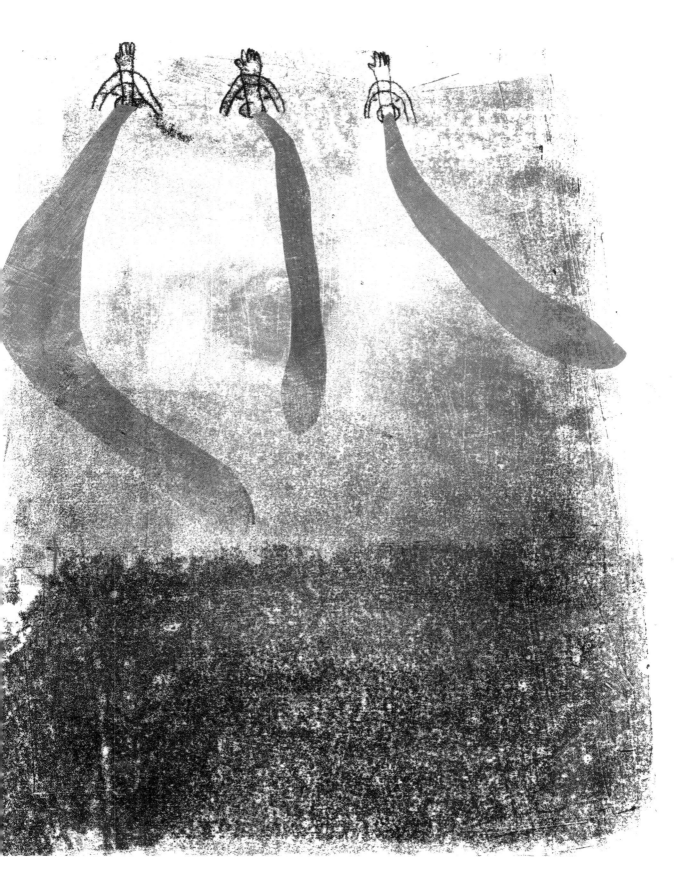

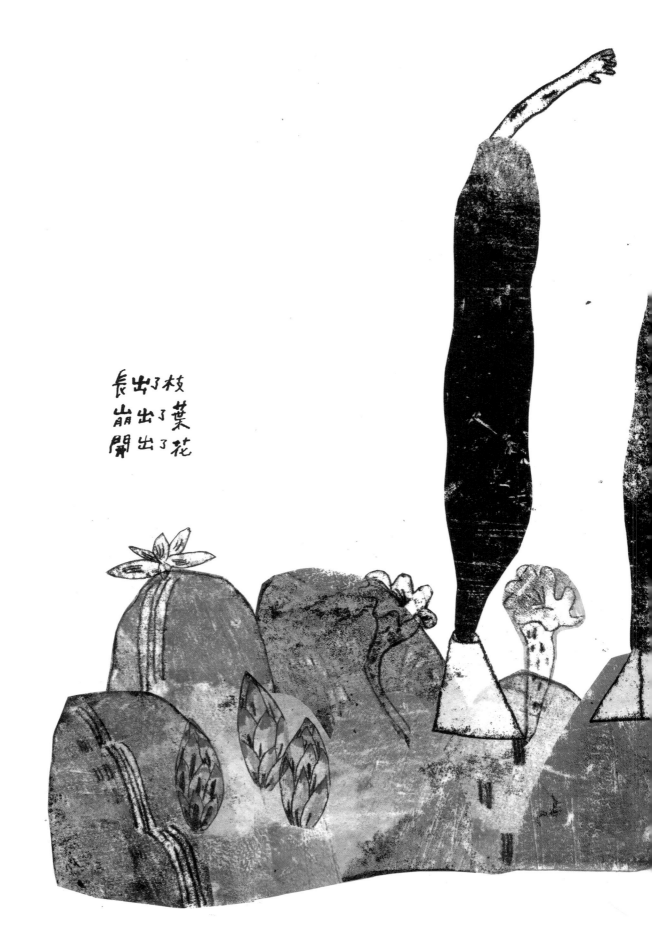

長出崩開
出了出了
枝葉花

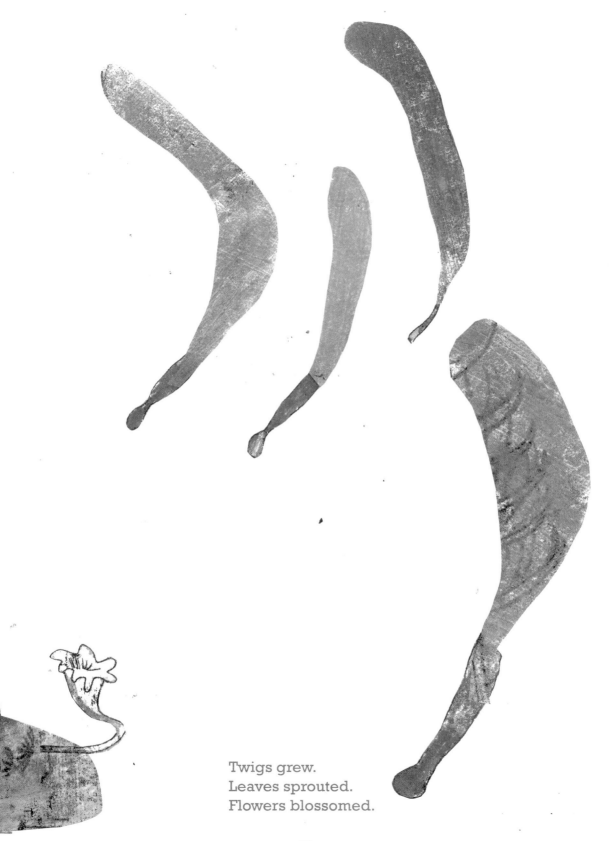

Twigs grew.
Leaves sprouted.
Flowers blossomed.

手蹬出了泥地
連跑帶滾

Floundering and running,
they freed themselves from the mud.

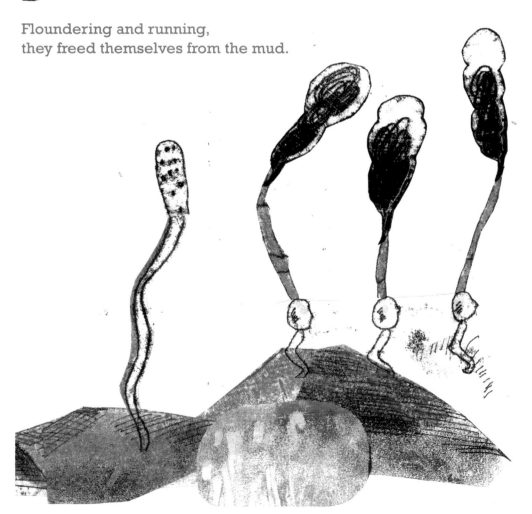

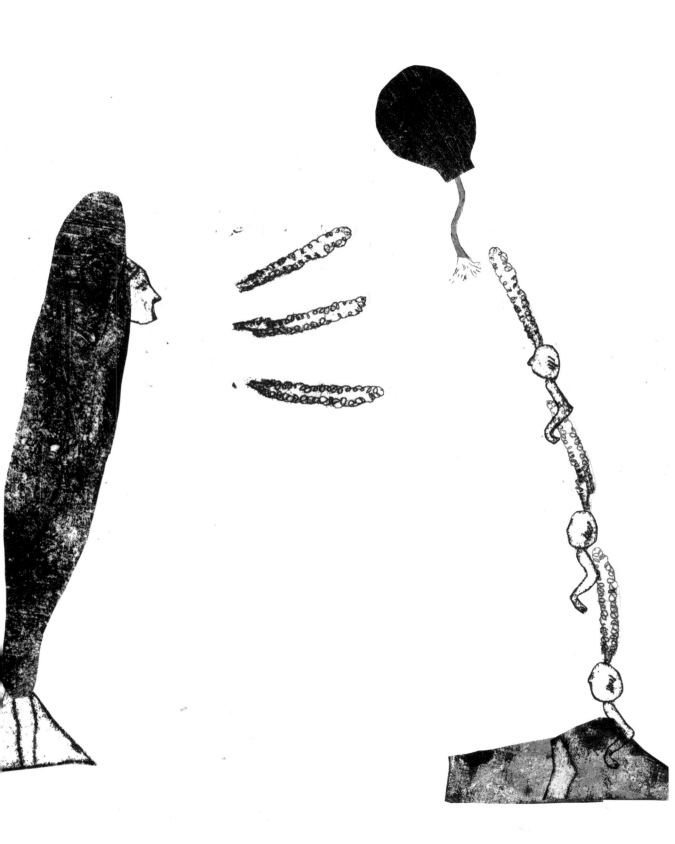

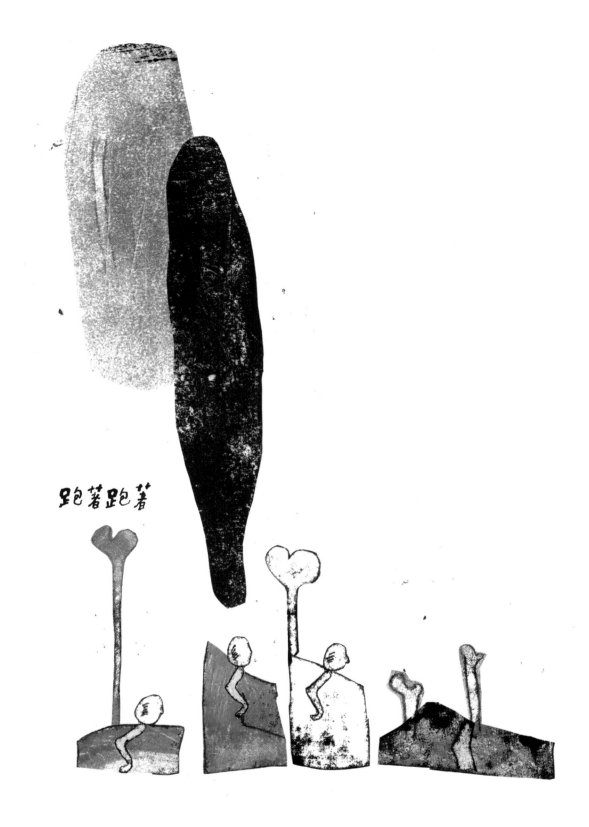

跑著跑著

Running and running,

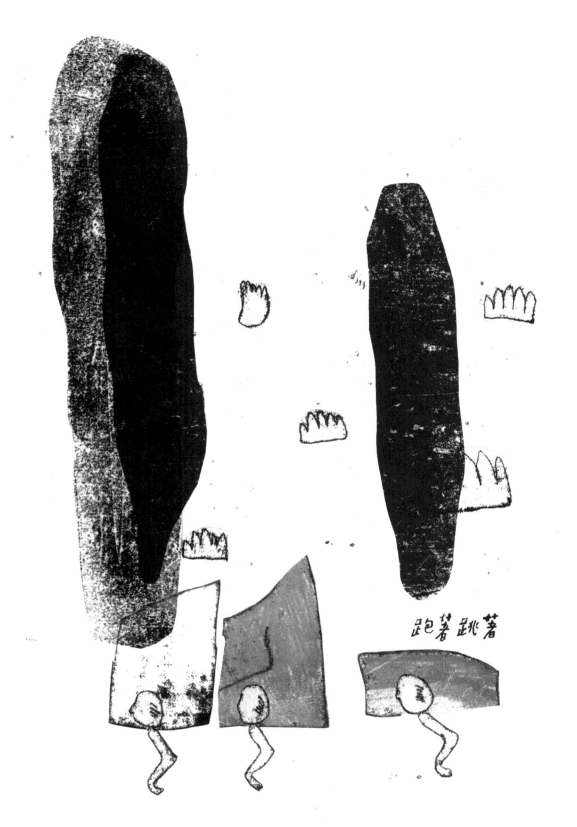

跑著 跳著

running and jumping.

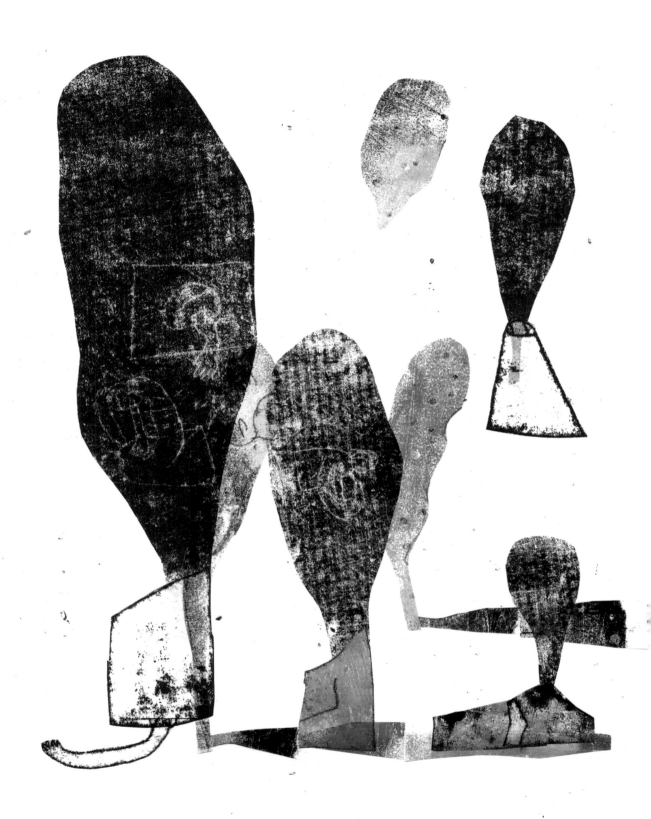

They got through one door after another.

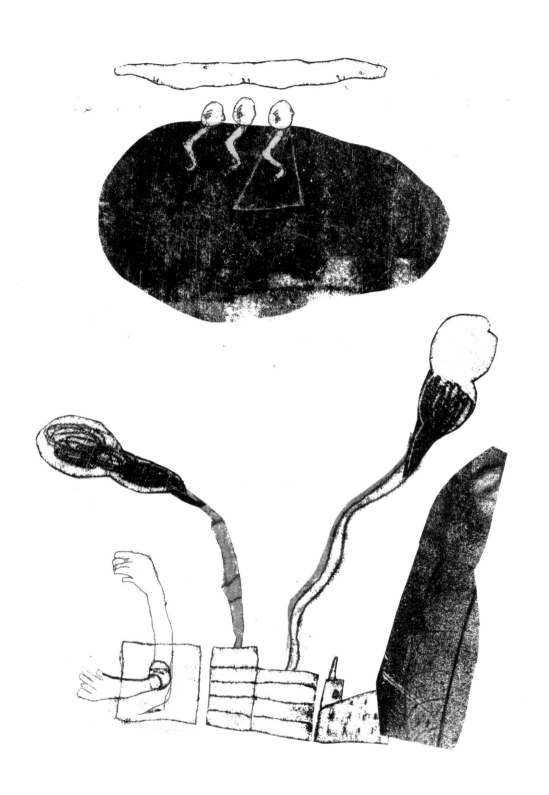

手跨進了一扇扇門

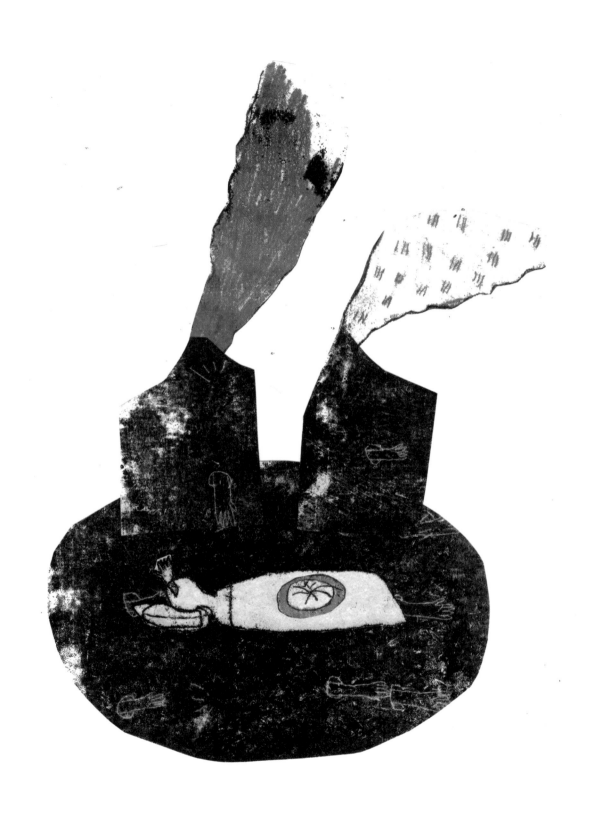

床上的人長出了手

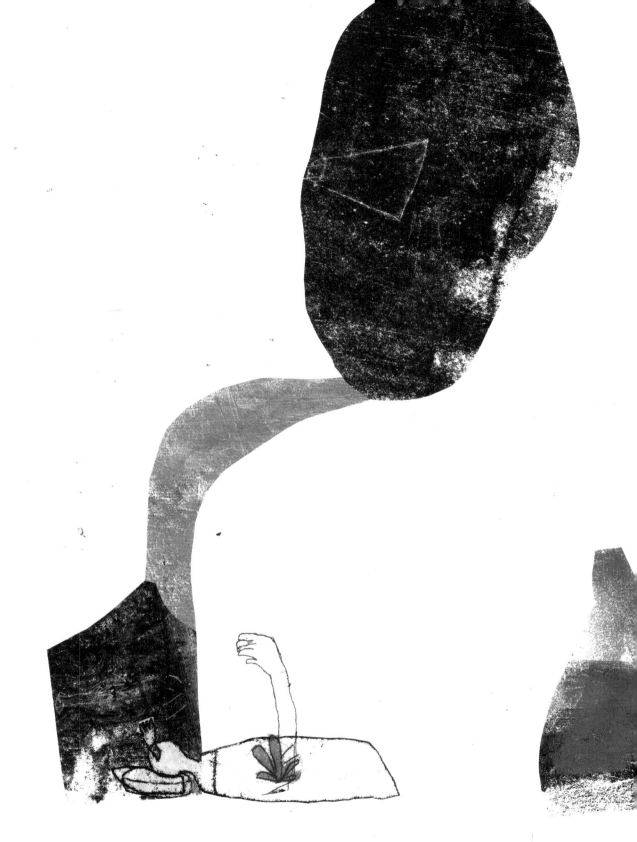

A hand grew on the man lying in bed.

「這是我的手！
我的手耶！」

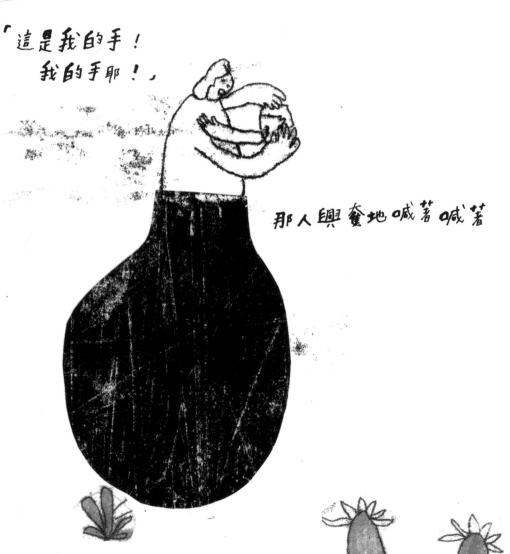

那人興奮地喊著喊著

"This is my hand!
This is my hand!"
He screamed and screamed in euphoria.

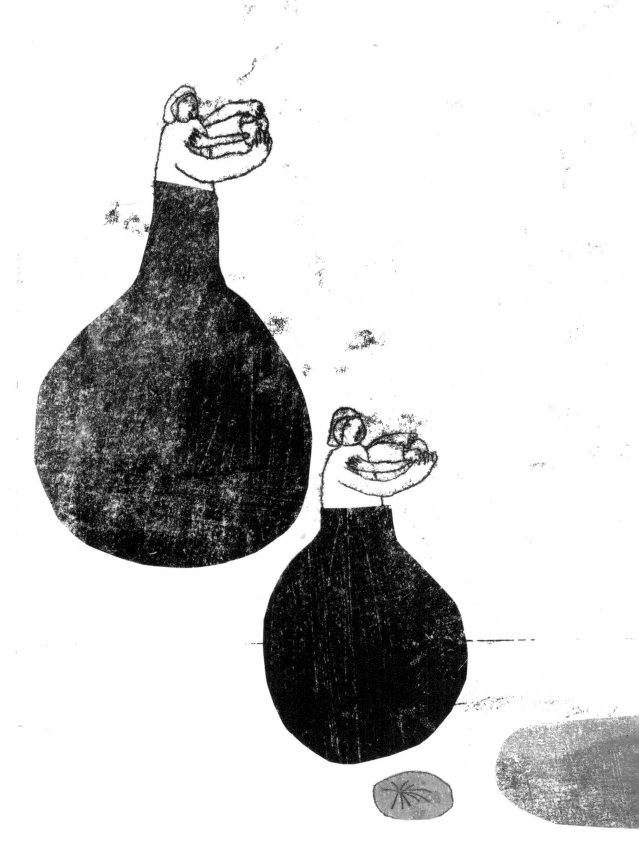

遠遠的山 遠遠的雲
都聽到了

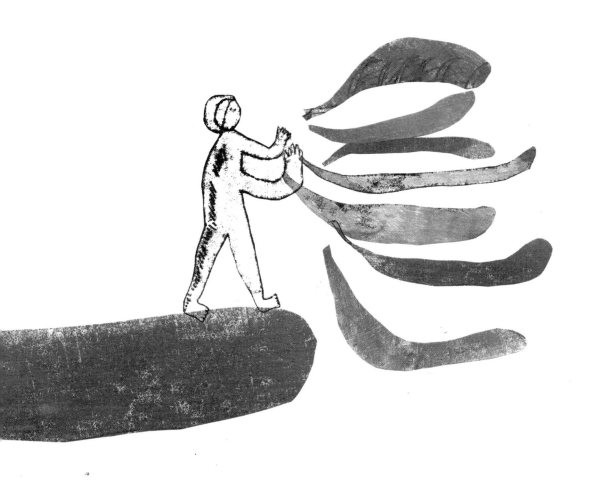

Even the mountains and clouds far, far away,
Heard this scream of euphoria.

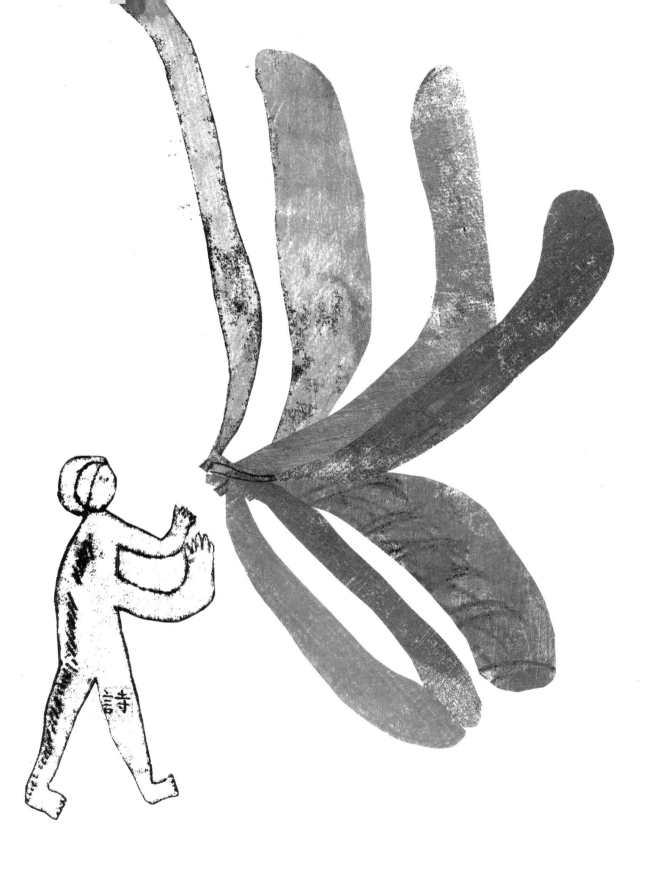

I must start with dirt. It must become stars.

The Practice of the Wild, Gary Snyder

我必需從泥土開始,
最後它一定變成星星。
　　　　　會

《禪定荒野》

Gary Snyder

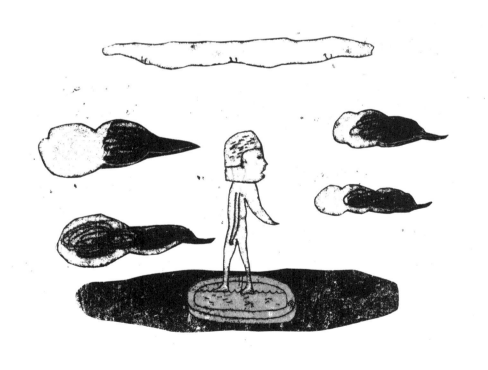

後記：就像
我本來是沒有手的人
重拾創作後像
獲得了一雙新的手

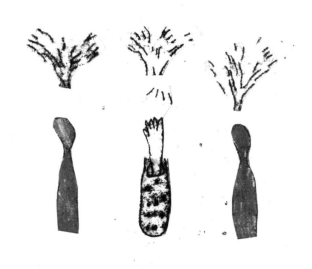

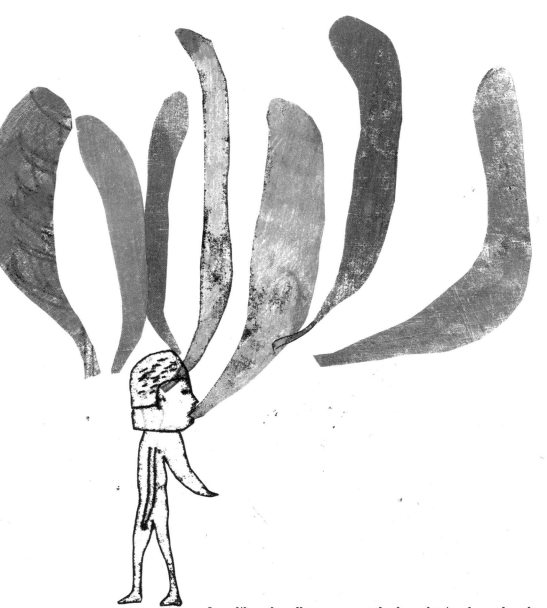

I am like a handless person who has obtained new hands
after resuming creative activities.

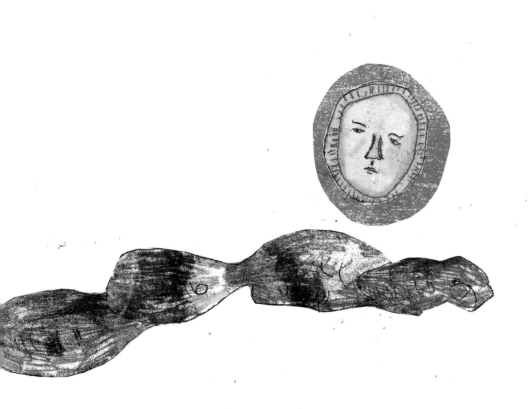

譯者

空雲 馬來西亞人,學習物理及社會工作,曾
擔任科研工作者及中學校長,目前旅居澳洲,
從事家暴資料分析工作。于 2000 初開始業
餘參與中英口筆翻譯,主要領域為佛法翻譯。

kongxudeyun@gmail.com

國家圖書館出版品預行編目 (CIP) 資料

異鄉之用 / 馬尼尼為 (maniniwei) 文 . 圖 . -- 初版 .
-- 新北市：依揚想亮人文事業有限公司，2022.11　　面；　　公分
中英對照
譯自：Trilogy of a Taipei migrant
ISBN 978-626-96174-1-8(精裝)

1.CST: 繪畫 2.CST: 畫冊

947.5　　　　　　　　　　　　　　　111017043

異鄉之用

文、圖 · 馬尼尼為 ｜ 發行人 · 劉鋆 ｜ 翻譯 · 空雲 ｜ 美術編輯 · Rene Lo ｜ 責任編輯 · 王思晴 ｜ 法律顧問 · 達文西
個資暨高科技法律事務所 ｜ 出版者 · 依揚想亮人文事業有限公司 ｜ 經銷商 · 聯合發行股份有限公司　新北市新店區寶橋
路 235 巷 6 弄 6 號 2 樓　電話 02-29178022 ｜ 印刷 · 禹利電子分色有限公司 ｜ 初版一刷 · 2022 年 11 月 / 精裝 ｜ 定
價 · 680 元 ｜

財團法人
國家文化藝術基金會
National Culture and Arts Foundation
NCAF